2/24

ONE BLOCK

A New Orleans Neighborhood Rebuilds

Photographs by Dave Anderson/Essay by Chris Rose

aperture

H-O-M-E

by Chris Rose

This is an art book. It is a statement. It is a love letter. It is a manifesto. More than anything, it is a photographic homage to the triumph of the human spirit, specifically as it is manifested in that most spirited, yet not-quite-triumphant place, New Orleans.

I am not an art critic or a photographer. I don't know the conventional vocabulary of the medium but let me try this: There is something very sturdy and muscular about Dave Anderson's pictures of people and properties, which is ironic, since all of the structures in this book—and most of the people, quite frankly—got pretty thoroughly smacked down by Hurricane Katrina.

What the wind didn't take, the water did, and with what's left, the job of putting it back together begins. It's been five years now. Some folks are frustrated with the pace of rebuilding but consider this: it took almost a hundred years to build these neighborhoods. You can't hammer and saw it all back together in a fortnight. Or a hundred fortnights.

Funny, though: For all the toil, sweat, and power tools presented in *One Block*, it's remarkably tranquil, sometimes dreamy. When I leaf through these pages, the sound I hear most is the gentlest clatter of daily conversation: the ritualistic greetings and inquiries of longtime neighbors, shared secrets, notes compared, pained laughter, whispered oaths, a child's teasing;

that beautiful sound—the hum and drone . . . of the human condition.

And sometimes, a dog barks, a rattling old truck lumbers by, and a circular saw fires up.

So, try something for me: Listen to this book.

• • •

One Block is the story of a neighborhood. Then a storm. Then rebuilding the neighborhood after the storm, rebuilding that one block, bounded by Chartres and Douglas Streets, Caffin Avenue, and—you couldn't make this part up—Flood Street. (Sometimes, in the post-diluvian economy, it seems that New Orleans manufactures irony with the same expertise that attends to our food and music.)

The block is located in the heart of New Orleans's Lower Ninth Ward, now one of America's most famous neighborhoods because this is where the flood waters reached their most grotesque levels of violence, smashing through the cheap levees and erasing everything in their path. On those blocks—twenty, thirty, forty of them—there was nothing left to fix. Not much to take pictures of today, other than overgrown lots, vacant slabs, and the occasional hopeful, prefab, eco-friendly domiciles of the new pioneers and settlers of the wasteland.

Away from the direct flow of Katrina's vengeful

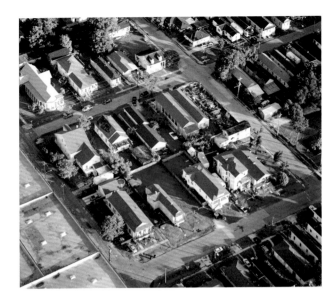

An aerial view of the block bounded by Caffin Avenue and Douglas, Flood, and Chartres Streets.

path, folks came back to everything bent, broken, or disappeared, and all the king's horses and all the king's men set about fixing the place up and calling it home again—this sorry-ass, beat-down backwater Humpty Dumpty town.

Home sweet home. One day at a time. Welcome. Be nice or leave. Please curb your dog. Fuck you, Katrina.

The people in this book, to an outsider, could so easily get trapped in all the clichés that abound in a story like this, folks right out of the American Handbook: Gritty, industrious, hardworking, God-fearing, standing their ground and facing their task— a dirty, miserable, and very unfair task—with limitless patience, equanimity, and good humor.

It takes strong hands, a hard heart, well-constructed tools, and a fortified soul. Lord Almighty: To live seventy years right here on this block, work hard all your life, carefully plot, plan, and parcel your future and then—and then THIS?

When the mean reds resurface in your head at a time like this, when the thought monsters clamber to get out of their cages deeply embedded in the dark pockets of the cerebral cortex—it happens to the hardiest of us—it's never a bad idea to seek the familiar comfort and justice of some Chapter and Verse. You can use a friend like Jesus in a time like this.

Somebody's going to be called to account for all this mess in the Afterlife and—trust me on this: You don't want it to be you.

. . .

Here's something interesting about the people in this book, something you may not divine until the third or fourth study: You know them. All of them. Not by name or anything like that, but you do know the people in this book.

They're drawn from the deep pool of universal experience. Everybody has a friend, family member, or office mate who's going through a home renovation, enduring it, surviving it—the terminology is oddly pathological in nature—and it consumes them. Literally eats them up. All they talk about. All they live, breath, and text.

For reasons apparent only to those who go through it, one national poll after another addressing the Quality of Life lists home renovations up there with divorce, getting fired, or a death in the family as the most stressful events in a person's life.

Funny, you'd think "improving" your home would be an occasion of joy and optimism. Then again, when your improvement project is undertaken not because you want better sunlight in your kitchen or for more closet space, but because your neighbor-

hood was wiped off the map by a hurricane and the failure of a federal levee system, well—that makes a little more sense. "This Old House," *One Block* ain't. By any stretch.

And you know how people are. They talk. In New Orleans, it's an art form, a way of life. Conversation is currency. So you sometimes learn more than you want to about your friend, family member, or office mate. You may not even know the difference between PVC pipe and grout, but you learn the intricate details of these people's wiring and plumbing as well as you know your Aunt Dolly's circulatory and cardiopulmonary systems because, well, that's all she talks about. She's a renovation in herself, but that's another story for another day.

Consider this: What if everyone you knew were these people? And I mean: Everyone. Literally, everyone you know, everyone you're related to, and everyone you work with! Going through this. All at the same time. Everywhere across an expanse roughly the size of Great Britain—yeah, that bitch Katrina's wake was bigger than most folks could ever know—and everywhere big and small and everywhere and everyone on this *One Block*.

This book. It's the story of those people. Those people and their houses, their castles, their forty acres, but the mule done gone. Out the door. If there was

a door, that is. But there is no door. No baseboards. No sheetrock. It's all either broken, missing, piled in a stack in the back yard, or on order. Everything's just plain ruin't.

Or maybe the door just got hung. Now that's always something to behold. Not everything has to be bad in this story. Maybe the door just got hung and you stare at it, so admiringly, hands on hips, head slightly cocked, amazed, simply amazed; you take it in and, well—it consumes you. It's prettier than any painting you ever saw on a museum wall. Another piece in the puzzle. Another scratch off the to-do list. One less sorrow. No man knows your burden. That door is a beautiful thing. The Baby Jesus wept at the sight of it.

You gotta love doors if you're going to do this.

The people I'm talking about, you know their story: They don't fish or go to the movies anymore. They can get their swing back, put air in their bicycle tires, or catch up on their reading some other time, when all the rest of this stuff is finished. There is the vicious cycle of eternal optimism and willful self-delusion: If you're waiting for the dust to settle, the longer you wait, the more dust there is and time will teach you, studies show, four out of five doctors agree: The Dust. Never. Settles.

Nevertheless, you plod on to Lowe's or Home Depot. Or, in New Orleans, you go to one of the

Preservation Society warehouses where they have old shutters, roof tiles, crown molding—and doors—stacked to the ceiling, all paint-chipped and even artful looking. And you get some of this stuff and you go home. To the house. Workin' it. Every day. Workin' it. And talking about it.

These Preservation Societies—good, honest, well-meaning folks—popped up all over the place after the storm, when all the water finally went back into the lake, where it was supposed to stay all along. And they are fiercely determined to keep New Orleans old. And all this stuff—tons and tons of stuff—was gathered from the streets and the yards and the fields and the levees and empty and busted down lots where maybe there was once a house before, maybe not, hard to tell after the shit went down.

The Thing, some folks call it. They can't bear to say her name. Like a scorned lover. Katrina done you more wrong, put a bigger hurt on you, than you would have thought possible. If someone told you this could happen, you wouldn't have believed them.

Then again, they did tell us this was going to happen. I remember distinctly, actually. In newspaper reports every couple of years leading up to it—The Thing—they definitely told us this was going to happen. But the numbers, statistics, projections—none of it made sense.

And then one day, everyone's dazed, confused, broke, and a little more than pissed off, down at the Preservation Society warehouses or wading through mountains of debris on the side of the road somewhere—"No Dumping." Heh. That's almost funny—looking for parts, pieces, planks, and patterns that look like they might fit their house, their creaky old lopsided lean-to with doors that never stayed shut anyway.

(Why are we so obsessed that the door hangs straight now, for Chrissake? For three decades, you put a stack of books against it to keep it open. And now that everything's in the shitter, you're Bob Fucking Vila with a carpenter's manual, rotary laser level, and a plumb bob?)

It's not like this neighborhood was right out of *Martha Stewart Living* or *Metropolitan Home* before The Thing but, Jesus!, really, look at it now. To be sure, a little rough around the edges. Nothing like it in the world. Except Haiti, of course. I guess we should count our blessings, we're not them. I'll bet they don't even have a fucking Home Depot.

Or Preservation Society. Where, and this part's a little crazy, you wouldn't be surprised to find your own stuff, because everything detached and just kind of blew or floated off somewhere and somebody else picked it up one day—coulda been months, even years, after The Thing—and it's their door now, not yours.

Goddam doors.

Windows. Bricks. Boards. Nails. Countertops. Appliances. So much . . . so much shit! So much for sale. Low Everyday Prices! All Inventory Must Go!

It seems like, before they even rebuilt a single school or church or community center in New Orleans, they'd built five Home Depots. They're everywhere. Nobody's complaining, mind you. We really needed them and God bless 'em for investing in our town. I'm just sayin', that's all.

Weird thing is, the Home Depots around here look an awful lot like church now. Every Sunday morning, the parking lots are full. Packed. Temples of lumber. Sinks and vanities lined up like little altars. Everybody's wearing their Saints jerseys and the whole family is up and out of the house early today, together.

All ye gather at the garden center.

. . .

They say that tragedy has a way of bringing people together. Think: 9/11. Or, remember *The Poseidon Adventure*? The one with Gene Hackman, Red Buttons, and Shelley Winters—not that crappy re-make. *The Poseidon Adventure*, and all those movies like that, with tidal waves or sinking ships or alien invasions or terrorist abductions; by the end of the story, everyone's like family now. Drawn together for a common cause. All the victims unite. Fall all over themselves living and dying for each other.

Yeah, it's a given that tragedy and adversity unite people. A common goal or a common enemy strip away the more superficial aspects of race, gender, religion, sexual orientation, or all the other artifice we impose upon ourselves, what with living with the burden of being the only species on the planet blessed with the capacities of rational thinking and empathy.

And opposable thumbs. Trust me, they come in handy at a time like this.

And when a storm claims her dead and her property with no regard for such prejudicial labels as we affix upon ourselves and others, who are we to do otherwise? It's one of the more uplifting chapters of history, sociology, and psychology textbooks; Human Behavior 101: Sometimes we do the right thing.

George Bush—he was President at the time—weighed in on the topic; a little late to the party and all that, but when he brought his big production crew to Jackson Square in the French Quarter a few weeks after the storm, he told us he was going to make everybody whole again, the flood being the result of crappy U.S. Gov'mint design, standards, workmanship, inspections, and all that.

Hmm. Man, don't get me started.

So the President toasted, "the core of strength that

survives all hurt, a faith in God no storm can take away, and a powerful American determination to clear the ruins."

Tell you what: probably the best thing he said in eight years in office. Of course, there wasn't really much follow-through on the federal level so everyone in the Lower Ninth and everywhere else had to pick themselves up and get to work and do it themselves. Which is fine. That's how we roll, is how the younger ones say it.

And it was, and still is, an amazing, inspiring, and powerful phenomenon to witness how everybody just got up, dusted themselves off, and—after burying their dead (at least, those they could find) and finding out where everybody who wasn't dead but wasn't here had wound up—they got to work, all of them together, all of them as one, a serious, serious God Bless America moment, like a rock, home of the brave, sea to shining sea, on the street where you live, united we stand, I'd like to teach the world to sing.

In perfect harmony.

Just do it.

It doesn't take a village, man. It IS the goddam village. And the Baby Jesus wept at the sight of it. Of that beautiful, beautiful door.

Here's something: You ever notice how—after some seventy-five years of popular music—from Satchmo to Streisand to the Beatles to Hannah Montana—most folks have come to believe that the most important four-letter word in the English language is *love*. L-O-V-E. All you need is, et cetera.

But down here in the Lower Ninth, they might have you believe otherwise. Because they—these people you know—just spent the last five years with their noses in it and if we/they/all of us have learned anything, anything at all, through all this completely preventable sorrow and nonsense, it is this: The most important four-letter word in the English language is *home*. H-O-M-E.

There's nothing like it in the world. The way it all unfolds, gets reclaimed, rejuvenates, stirs the soul—in the Gulf South, in New Orleans, in the Lower Ninth Ward, on this *One Block*—this honest, uncompromising, and lovingly wrought tale of, yeah—you knew it was coming: The Human Condition.

You've never seen it quite like this before.

Until now.

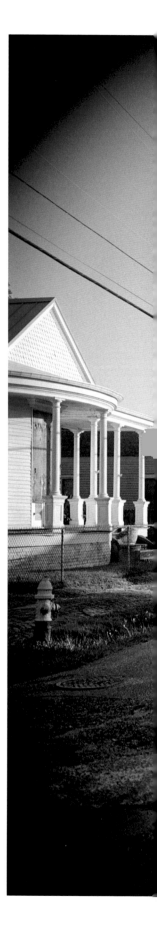

8 Looking north on Flood Street from the Douglas Street intersection in May 2007.

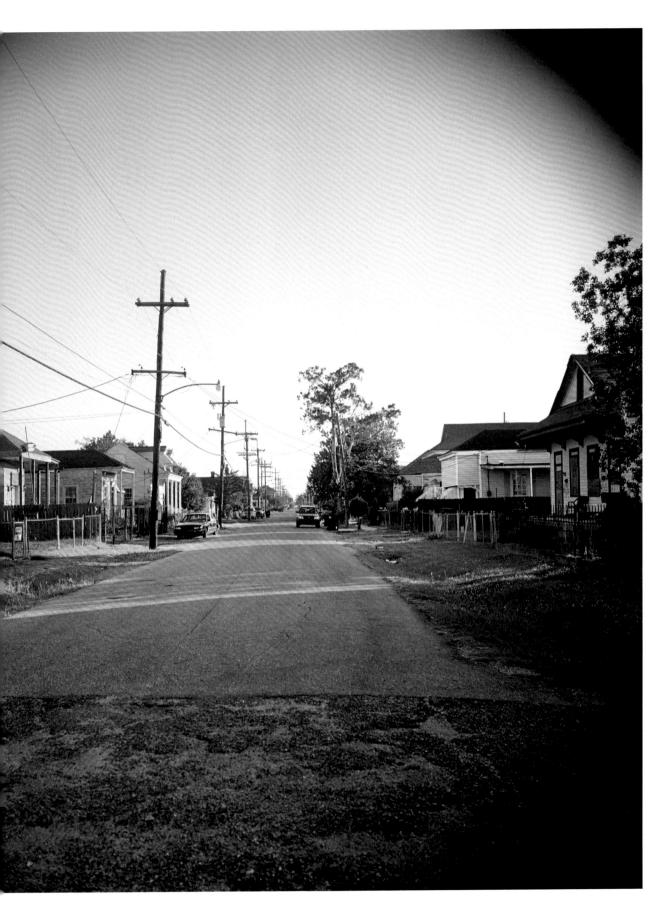

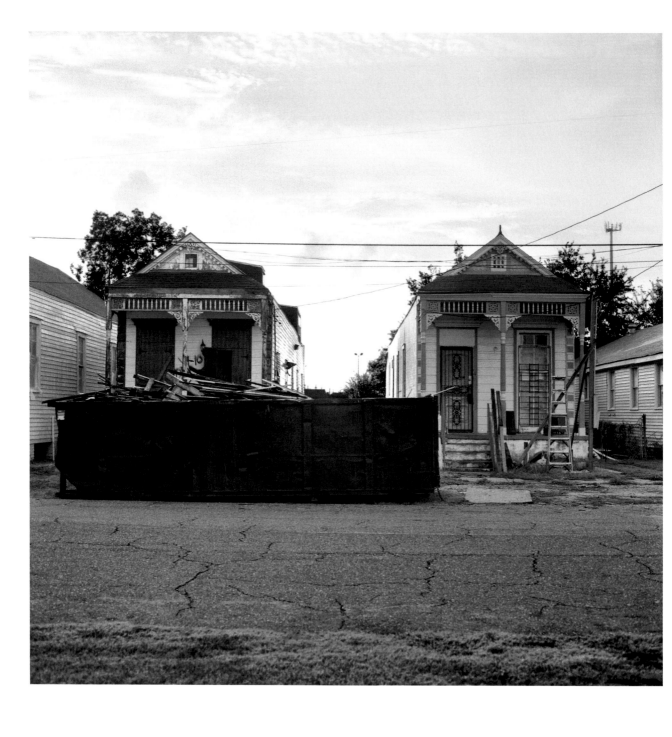

"There's been so many times that I wanted to leave. It has wreaked some havoc on my mind . . .
I'm not totally cured of that yet." —Lisa Perilloux

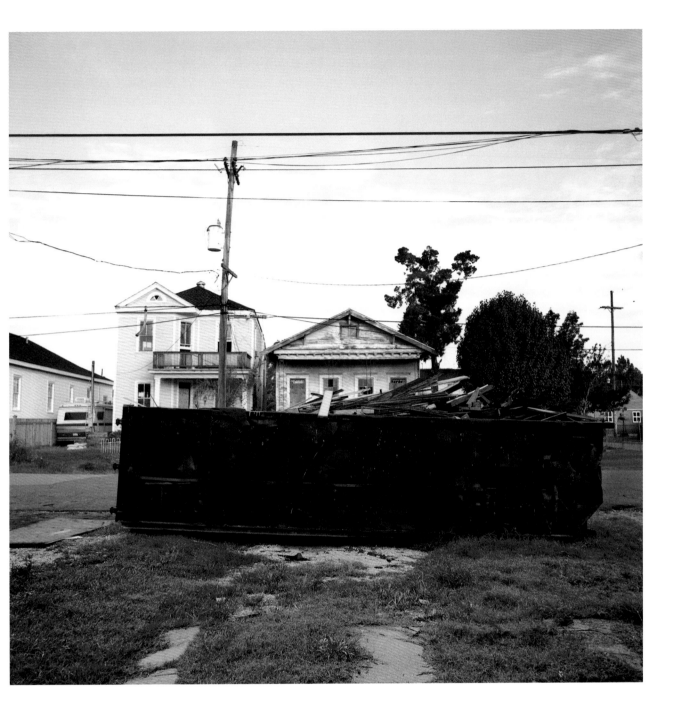

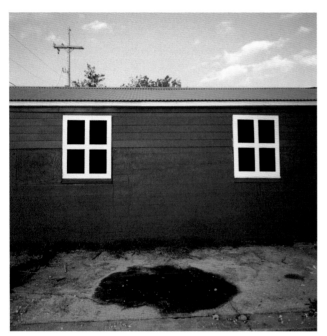
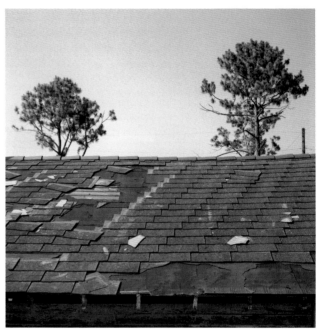

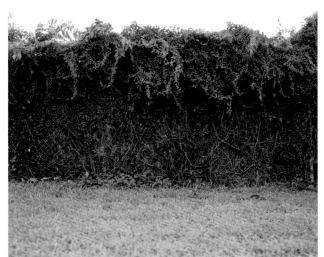

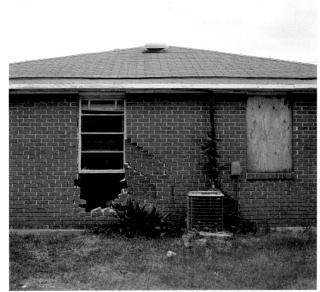

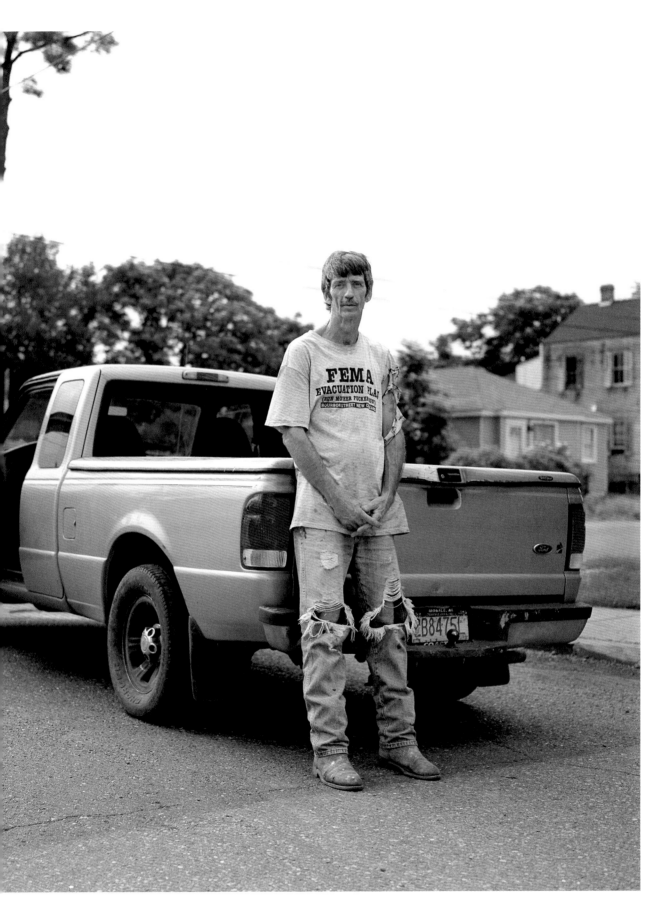

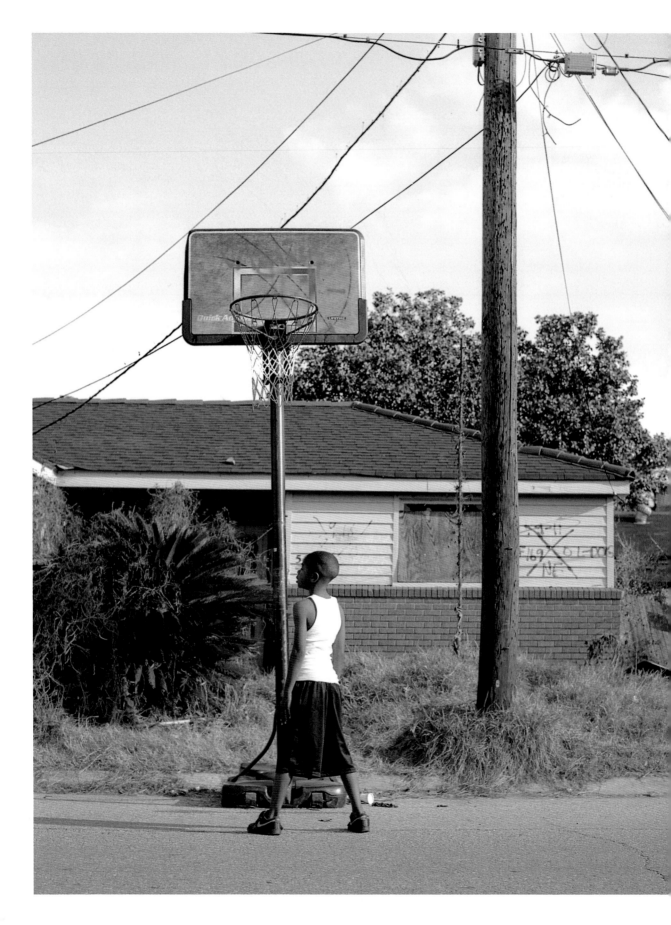

A basketball hoop appeared by this house on Chartres Street in early 2006 and was immediately adopted by neighborhood kids. The hoop was slowly destroyed over time, only to be suddenly replaced. This process was repeated several times.

"I lost all my stuff. Everything." —Maxine Richardson, on the steps of her FEMA trailer with James Clark, a friend and neighbor who allowed Maxine to locate her trailer on his property because there was no room on hers.

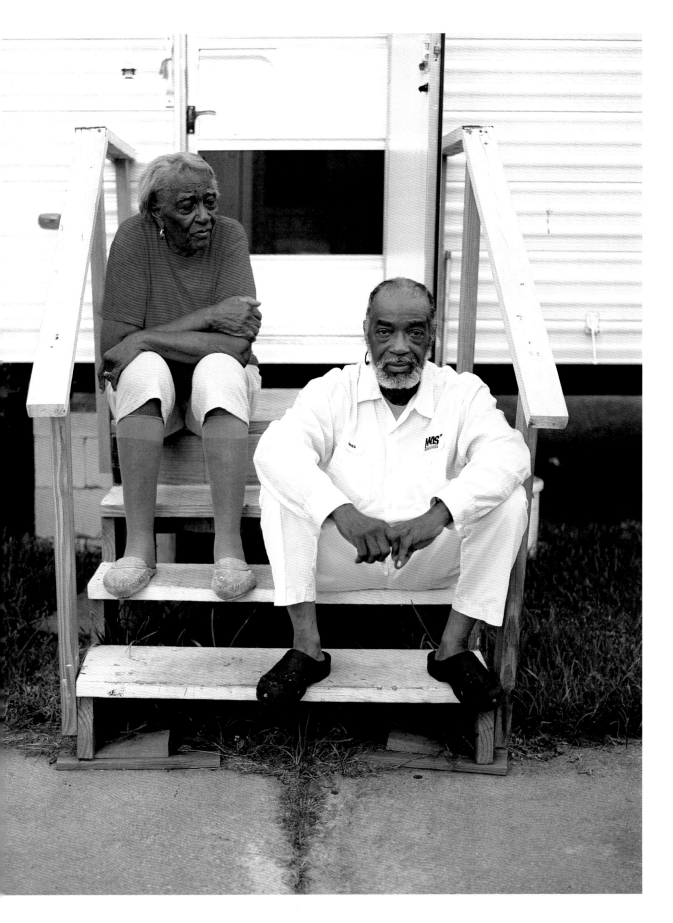

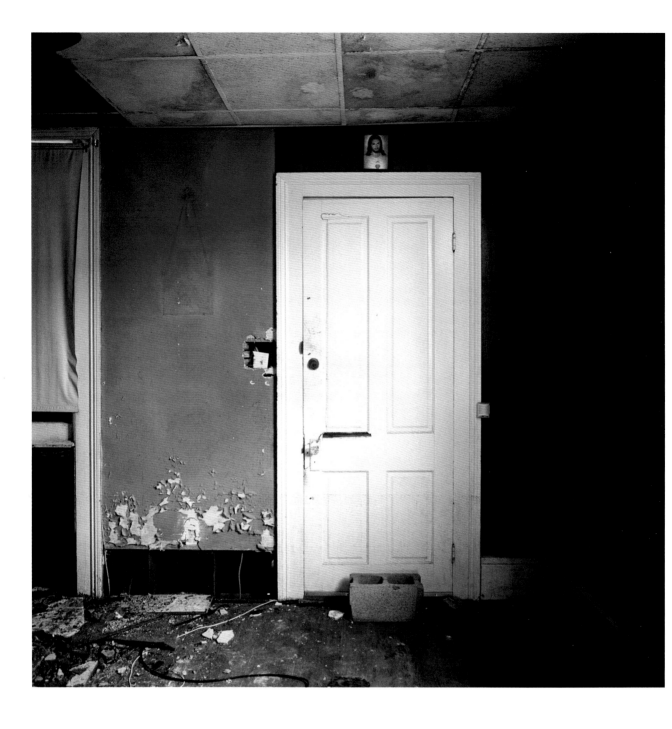

"It was three weeks before the flood and I was going out with some friends for a lunch and a bingo game. I walked out of the house and I had the door open and I looked back around my house and I said, 'Oh, Lord, it took me so long to get everything I want, but now I got everything. I could not ask for another thing,' and I said to Him, 'I sure am grateful and thankful for it.' Wasn't three weeks before that storm came along and took it all away . . . I guess I thanked Him too late." —Doris Cefalu

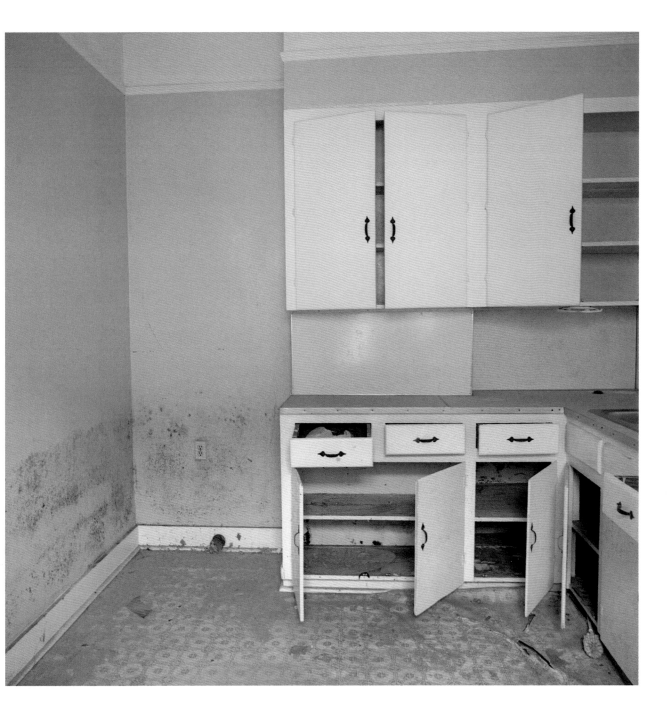

Ward "Mack" McClendon upstairs in his home after it was gutted in 2006. Mack's renovation was suspended for over two years while he concentrated on founding The Village, a community center for the Lower Ninth Ward. He lived in a FEMA trailer during that time.

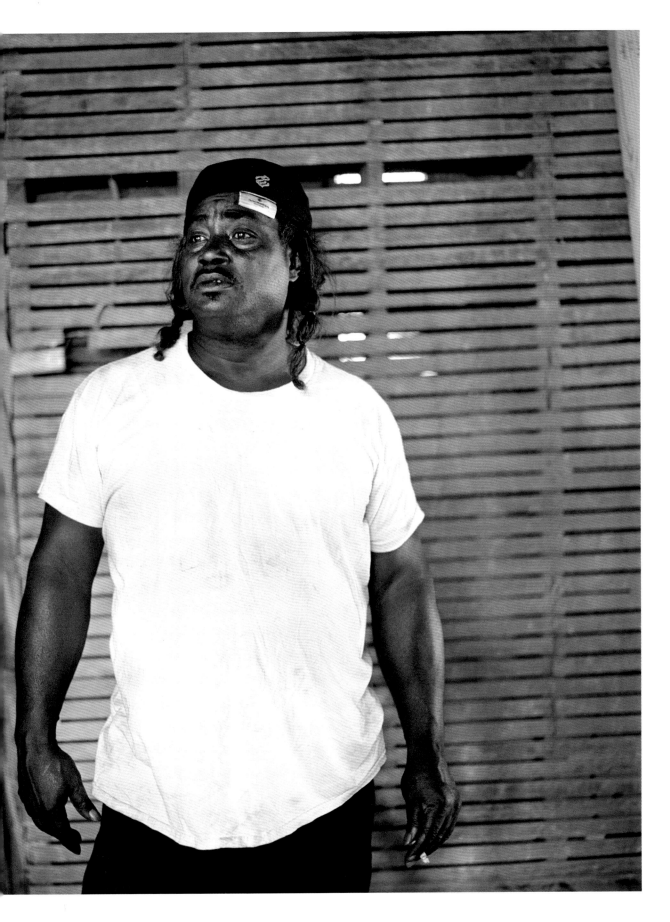

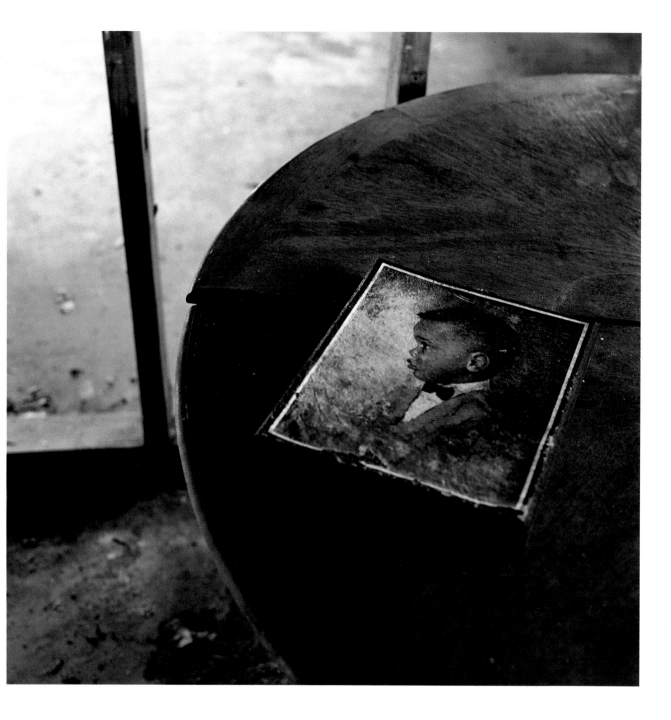

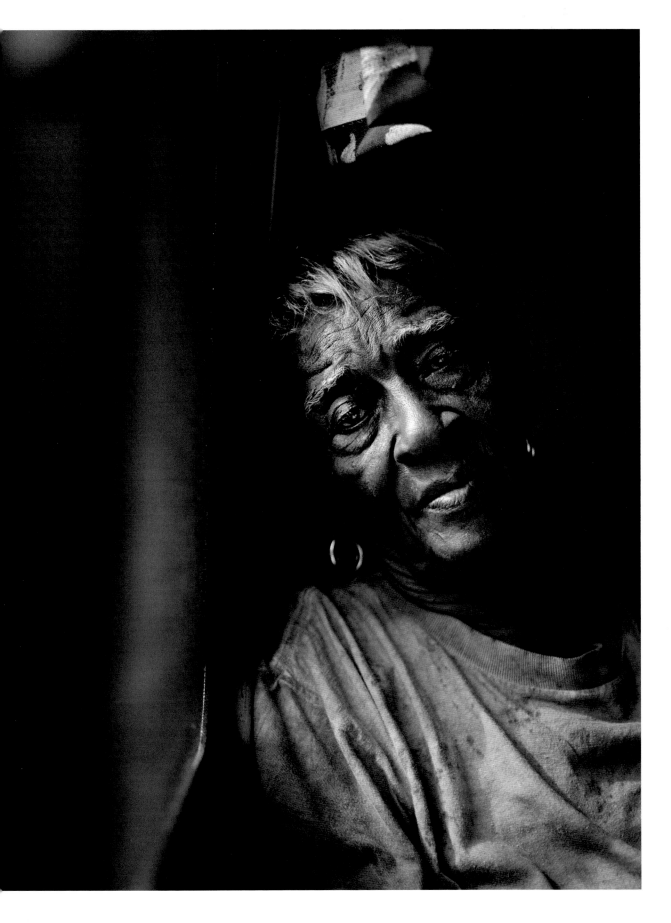

Greg McMorris at work on his parents' home on Caffin Street. His mother, Georgia, and father, Luther, left the city during Katrina and settled in a small rural community near Natchez, Mississippi, where they found a measure of peace. Said Georgia, "There's no gunshot sounds."

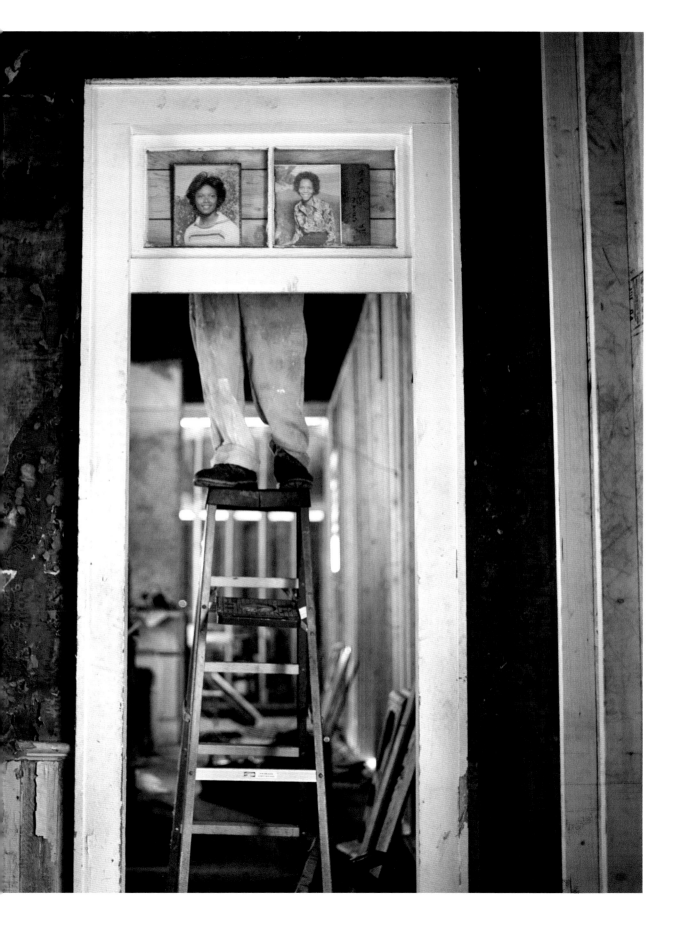

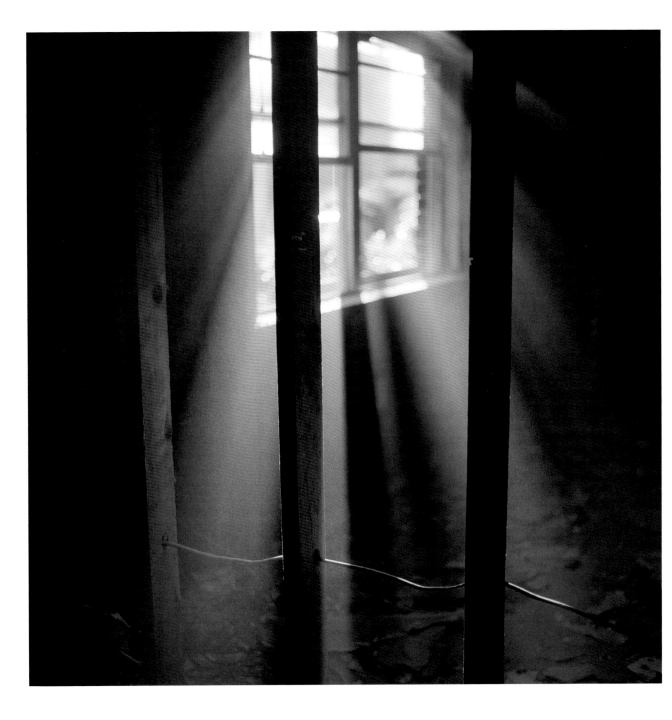

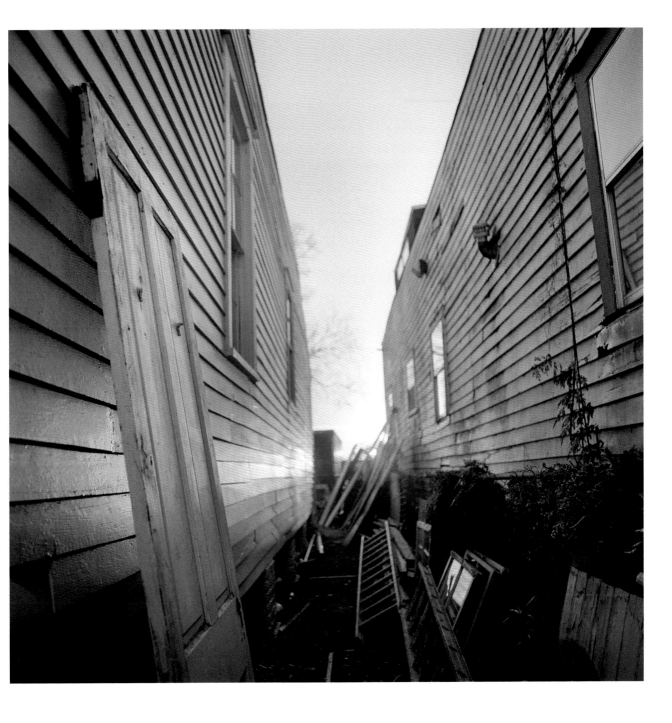

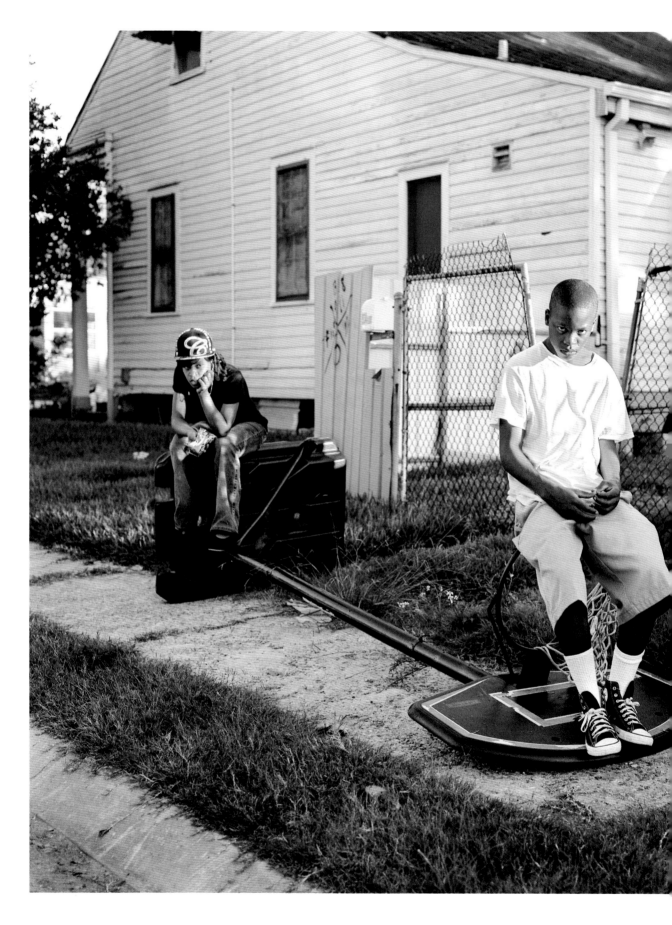

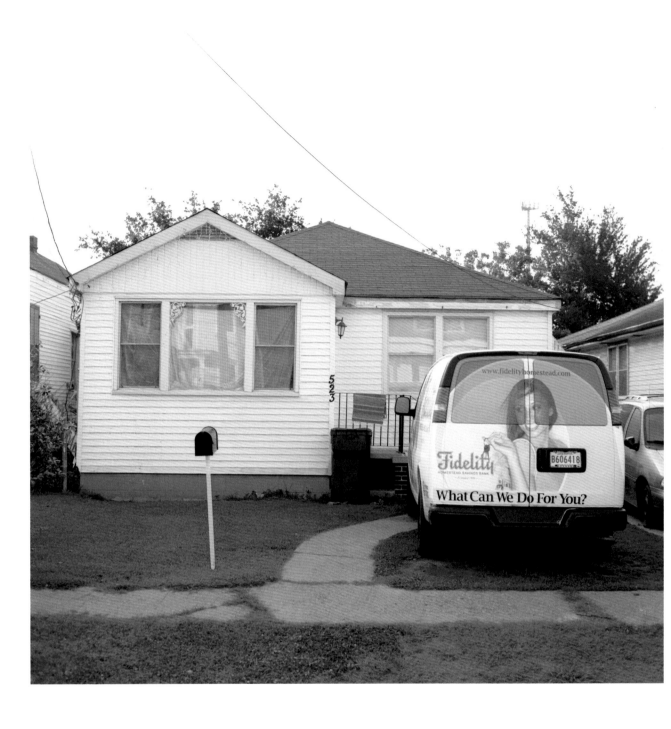

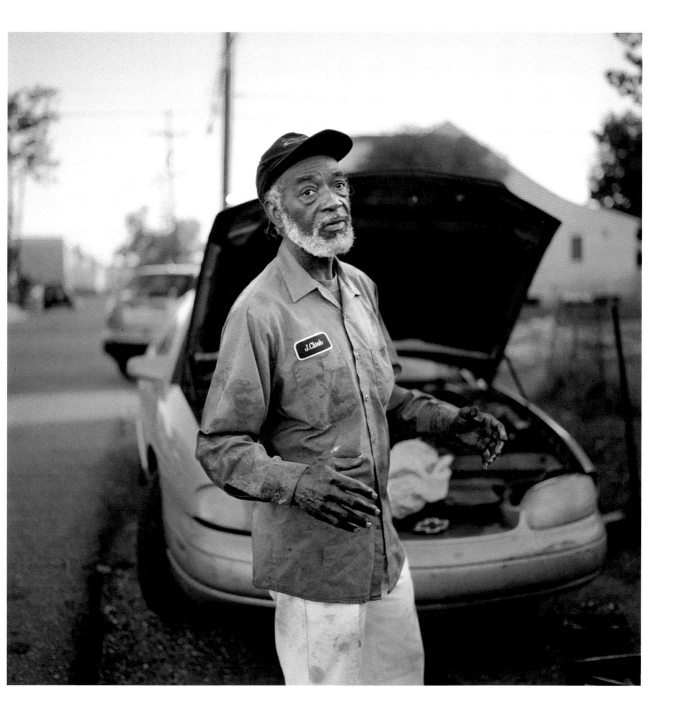

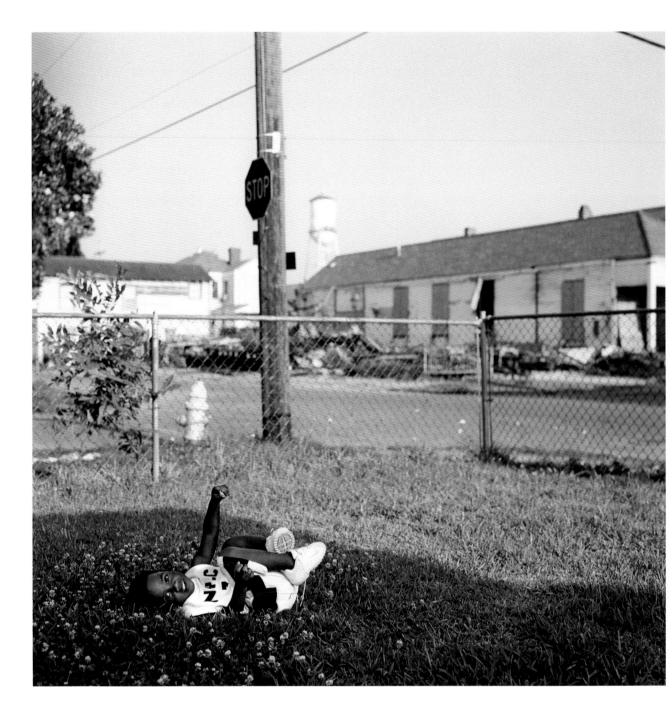

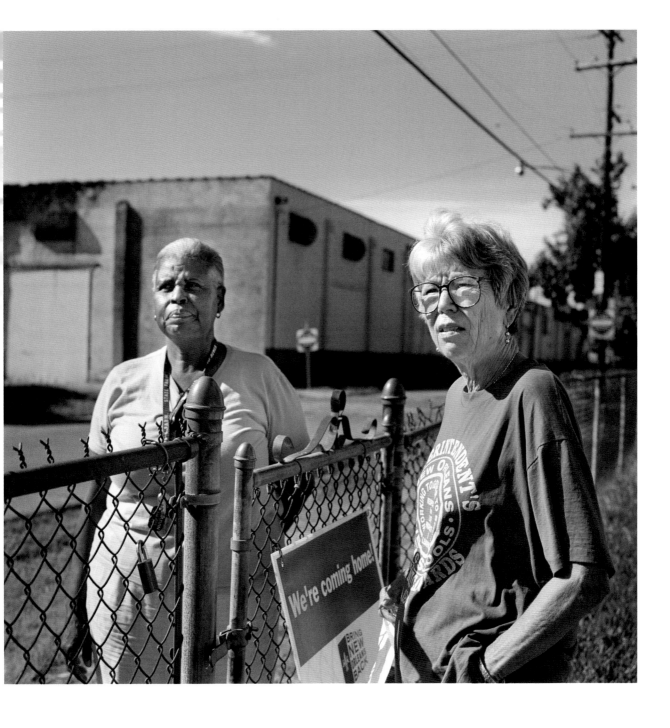

"Augustine is back and that's a great comfort to me. She's a good friend and between the two of us we keep a pretty good watch of what goes on around here. I wouldn't feel as comfortable as I do if Augustine wasn't here." —Stacy Rockwood (right) with Augustine Greenwood (left)

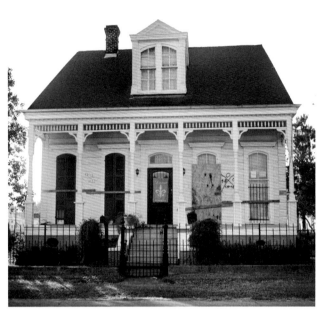 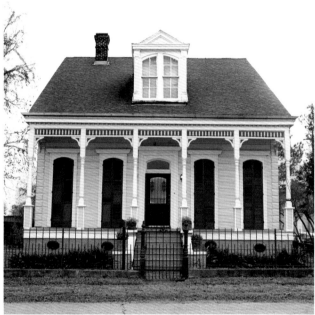

Augustine Greenwood's house in May 2007 and December 2009.

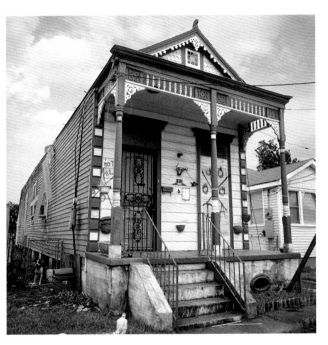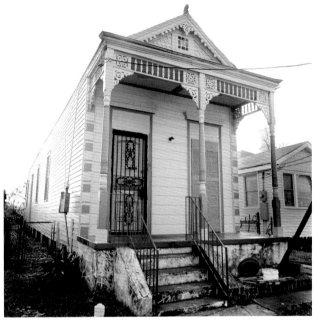

The McMorris house in July 2007 and December 2007.

"I'm hangin' in there. That's all I can say. I'm hangin' in there." —Maxine
Richardson, on her porch, after she was able to move back into her house.

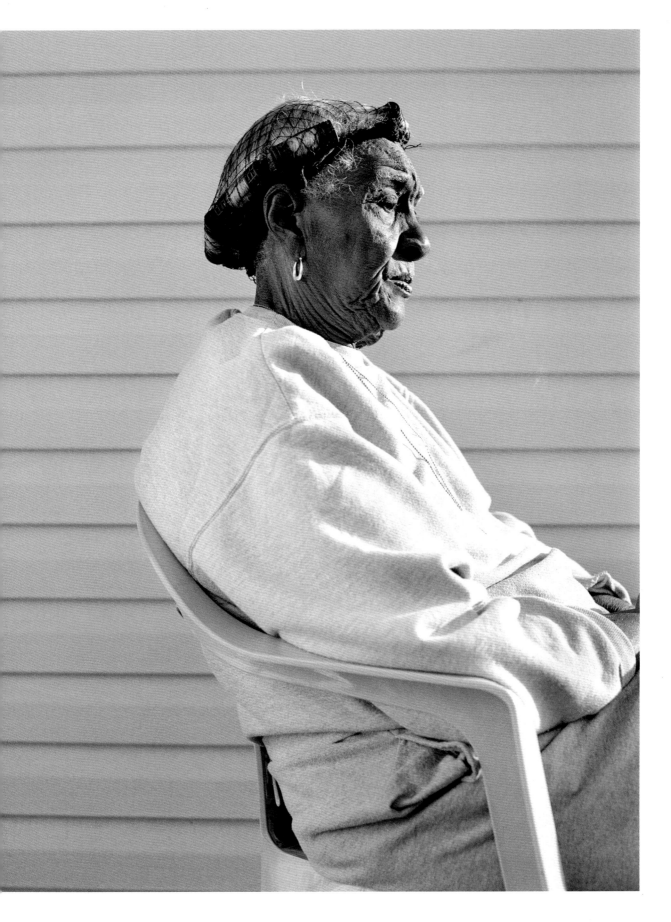

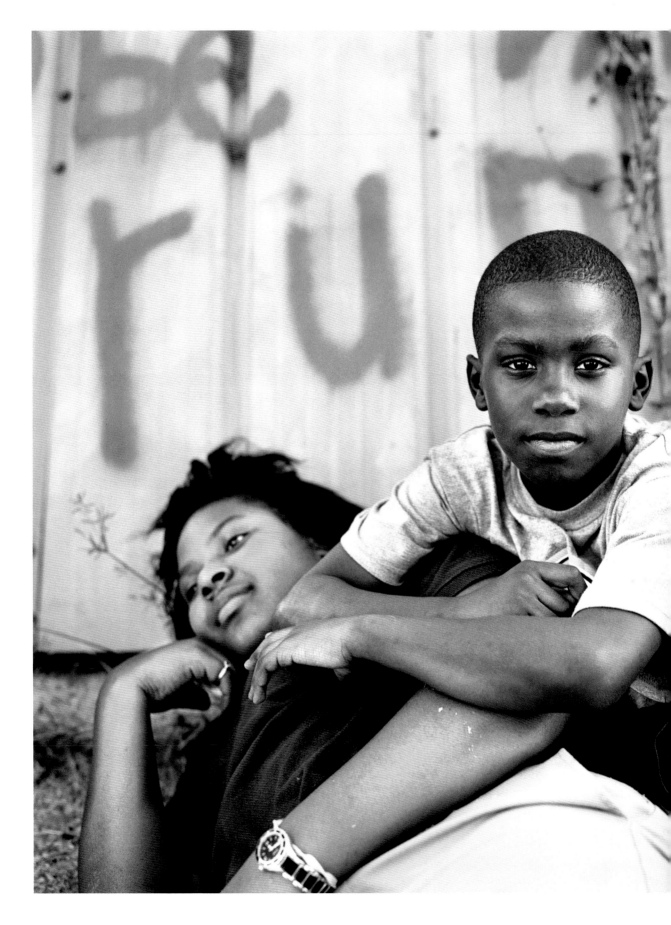

Joseph Pomfrey, a New Orleans native, returned to the city after the storm and found work helping Mack McClendon on miscellaneous projects while living on an old couch in Mack's junkyard.

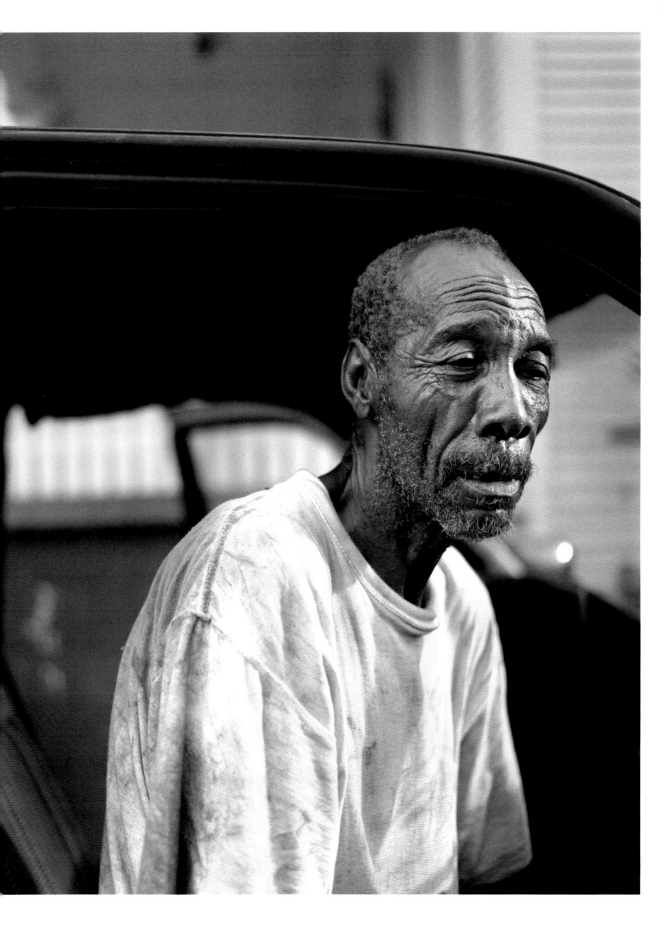

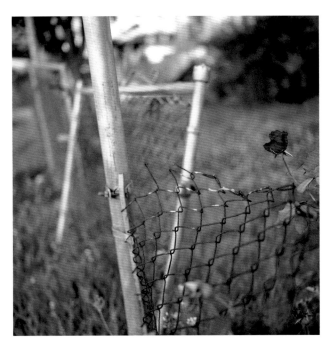 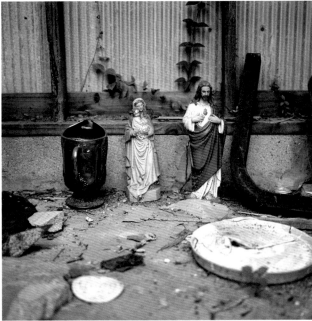

"We've been here for years and the neighborhood was always quiet. We never have no problem in our neighborhood and our neighbors are close and everybody look out for each other, ya know?" —Hermanese Rogers

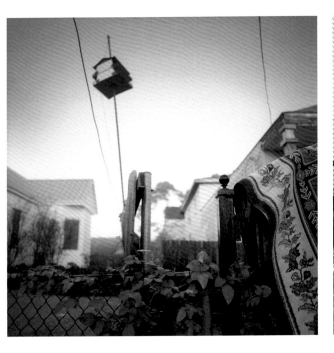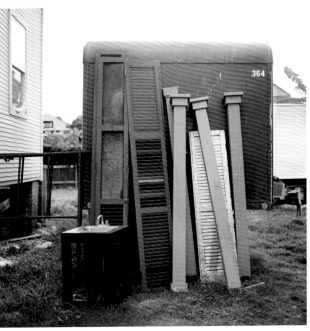

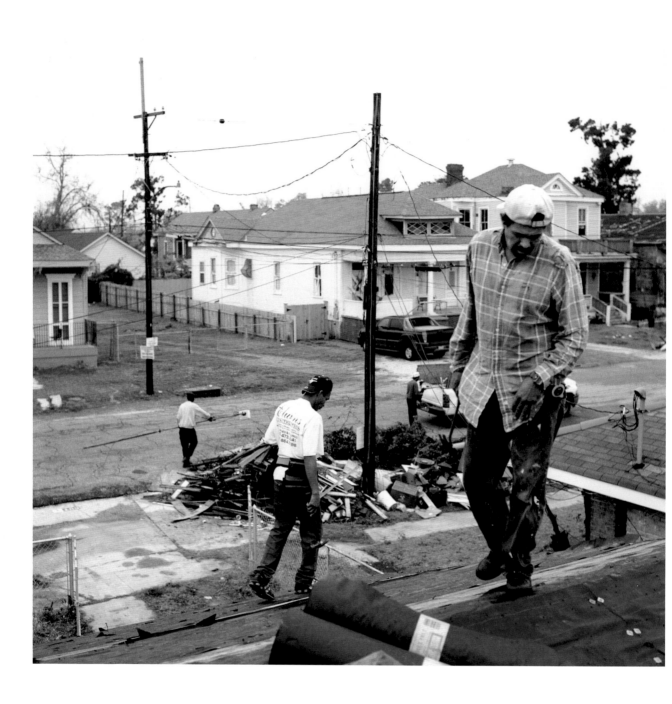

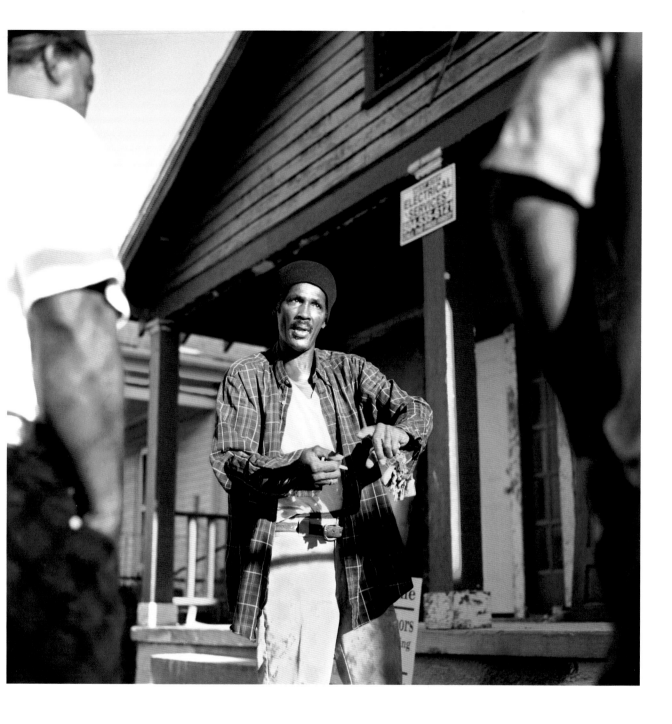

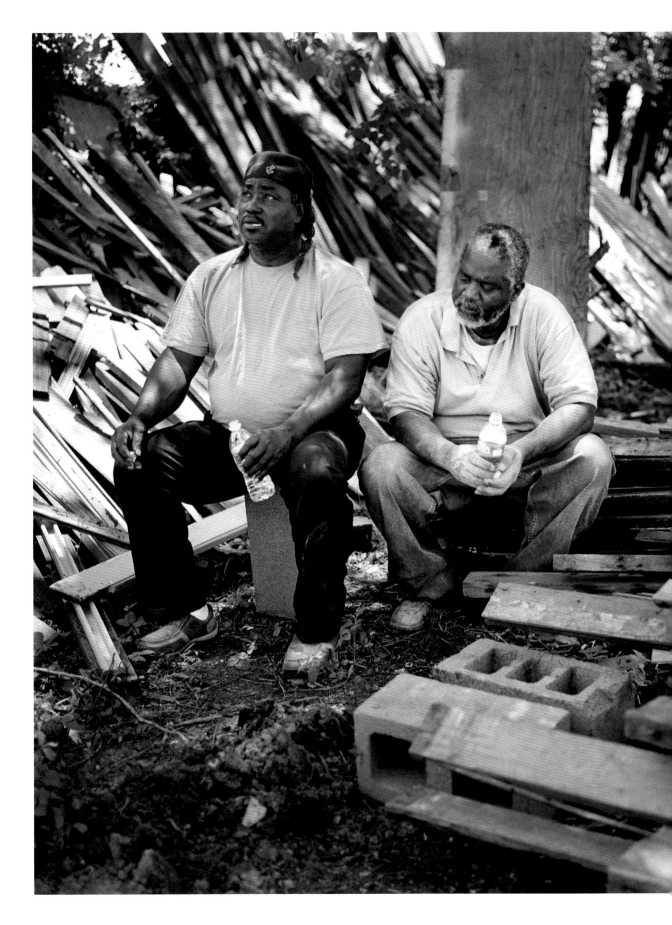

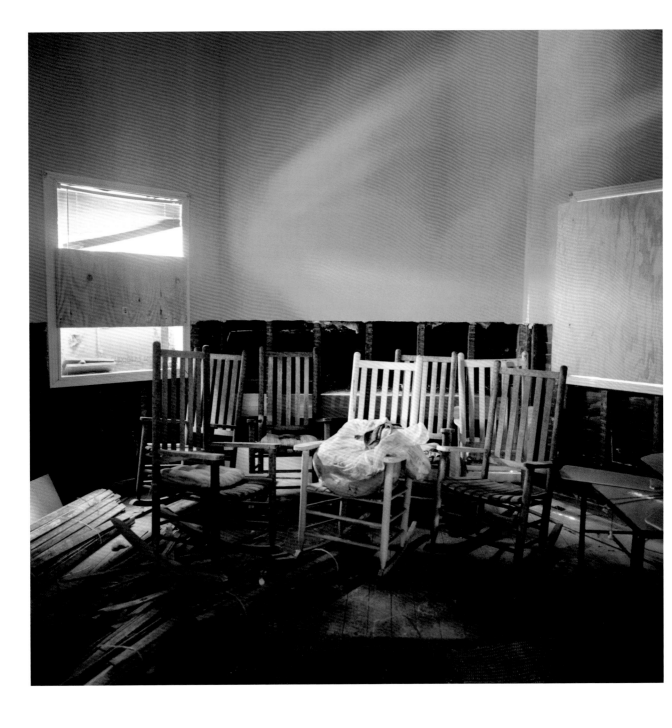

"Any progress is good. You know if I leave and come back in the evening sometimes I feel like, 'Well, they didn't do very much today.' But when I sit there and watch, then I see what all work went into it; how they had to prop this and move this and take that loose in order to get to what they were tryin' to do. Then it has a bit more meaning." —Nathalie Alexander

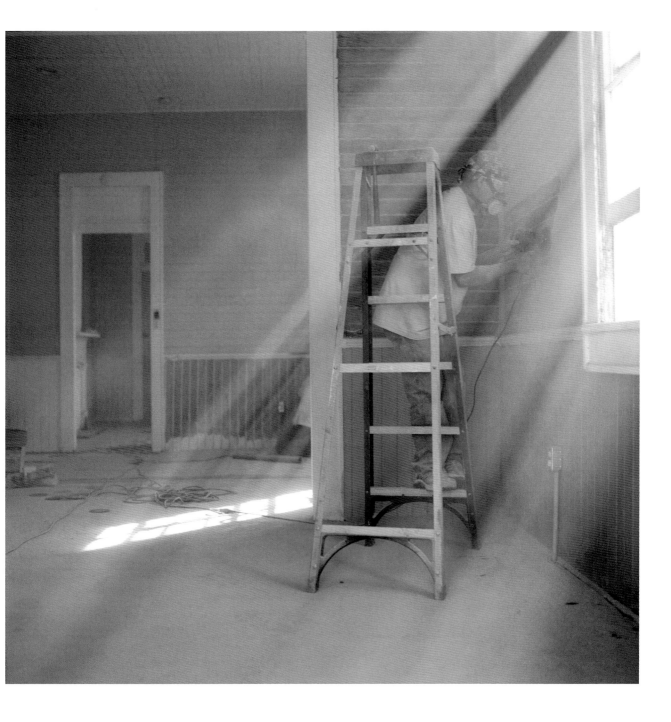

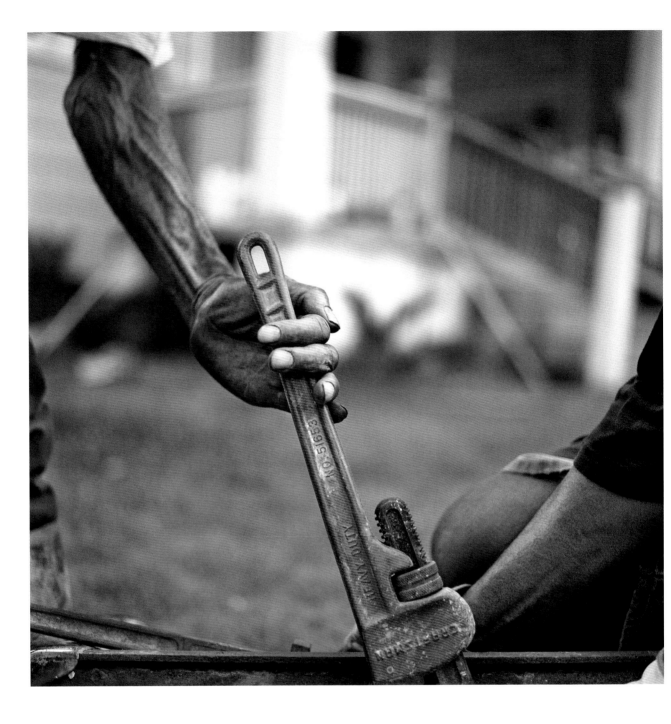

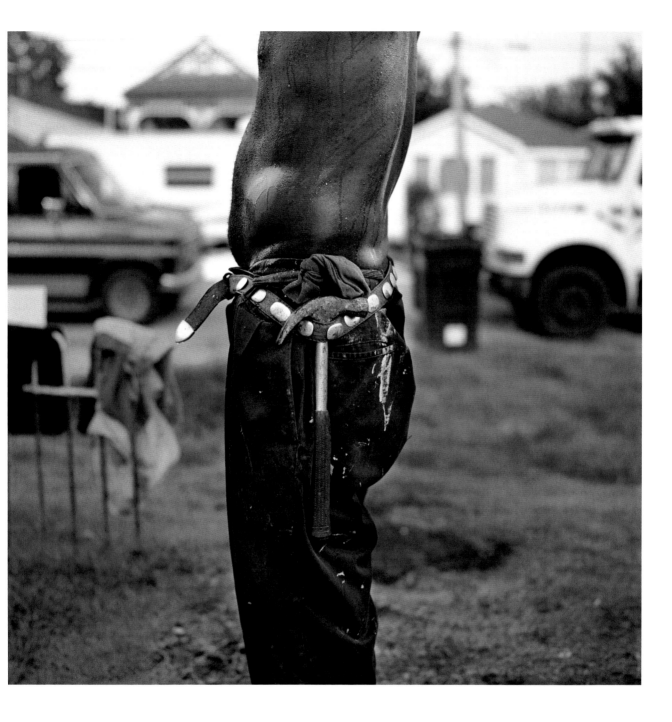

"I started collecting doors because I never knew the measurement of my doors. I didn't have that mind to take door measurements and leave them in the car. Long story short, I've got a bunch of doors. Mack's got a bunch of doors, John's got a bunch of doors, Keith's got a bunch of doors too. I think we all suffered from the same door enthusiasm." —Markus Wittmann

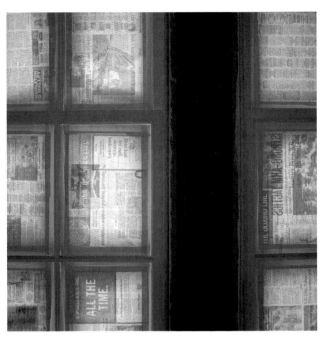
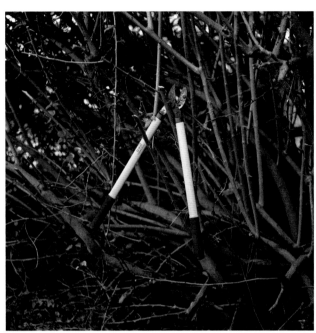

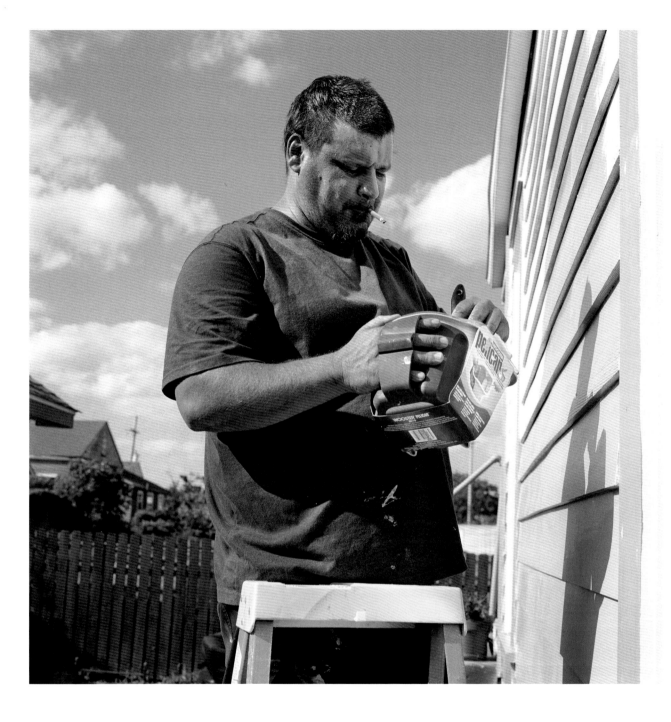

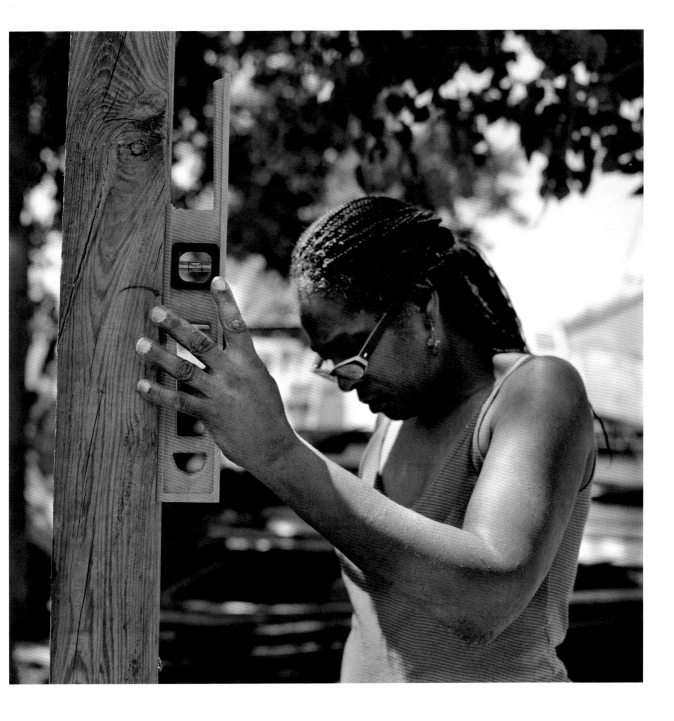

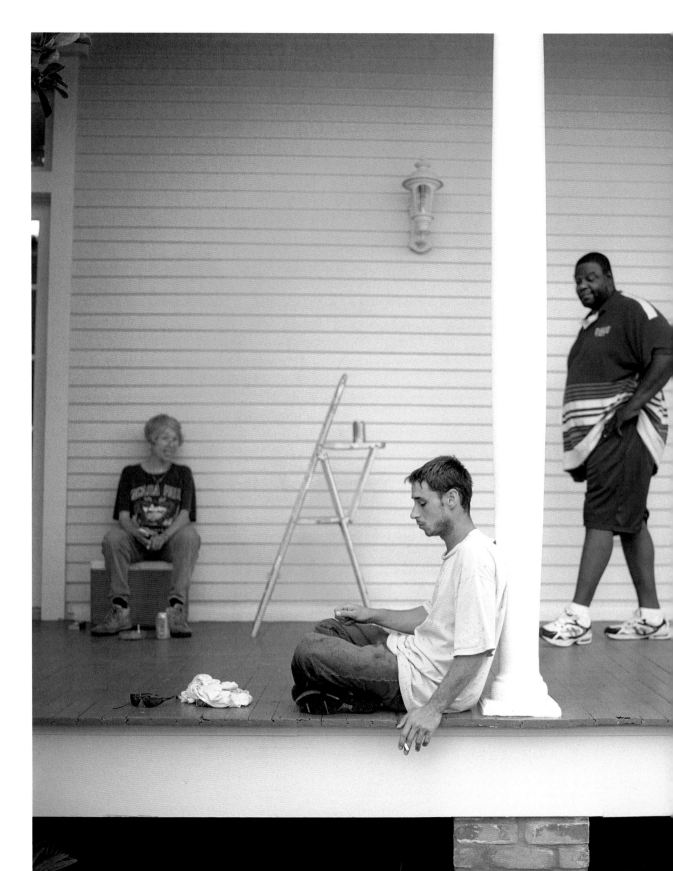

"This is my fourth contractor: the first one I hired, I fired; the second one I hired, quit; the third one I hired, I fired; and the fourth one, I want to fire! The carpenters got deported." —Stacy Rockwood

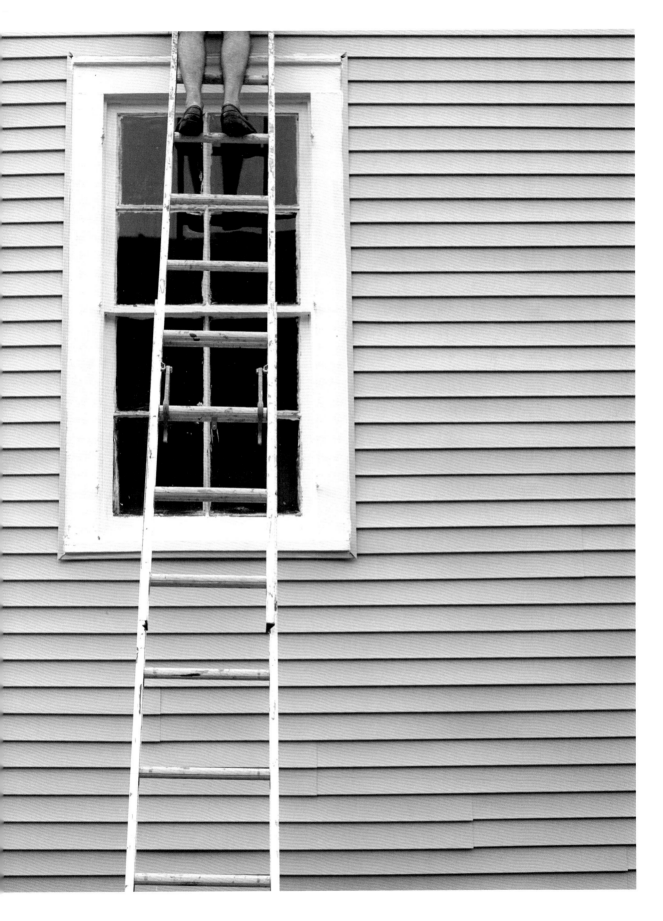

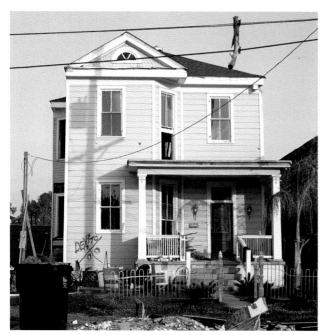 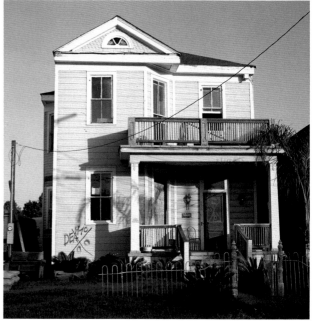

Mack McClendon's house in May 2007 and October 2007.

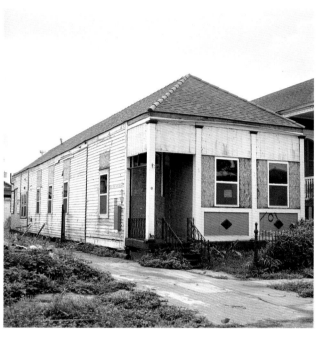
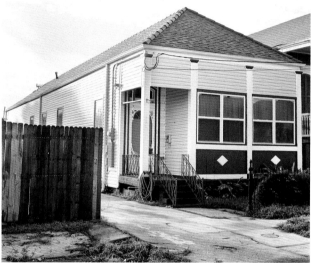

Maxine Richardson's house in July 2007 and January 2008.

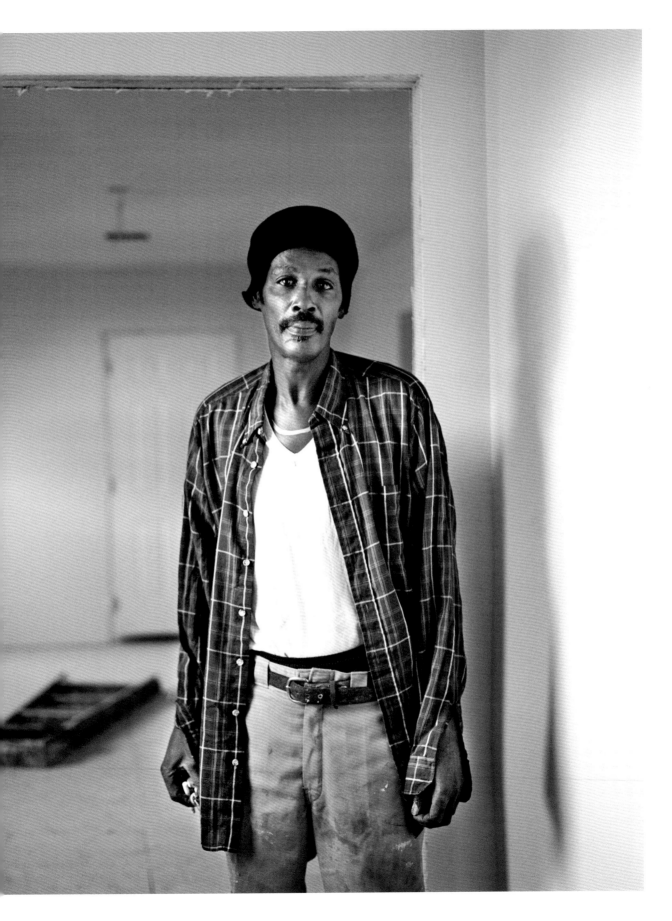

Contractors preparing new windows for Maxine Richardson's home. After the
installation, Maxine learned that the New Orleans Historic District Landmarks
Commission deemed the windows to be historically inappropriate and that they
would have to be replaced at her own expense.

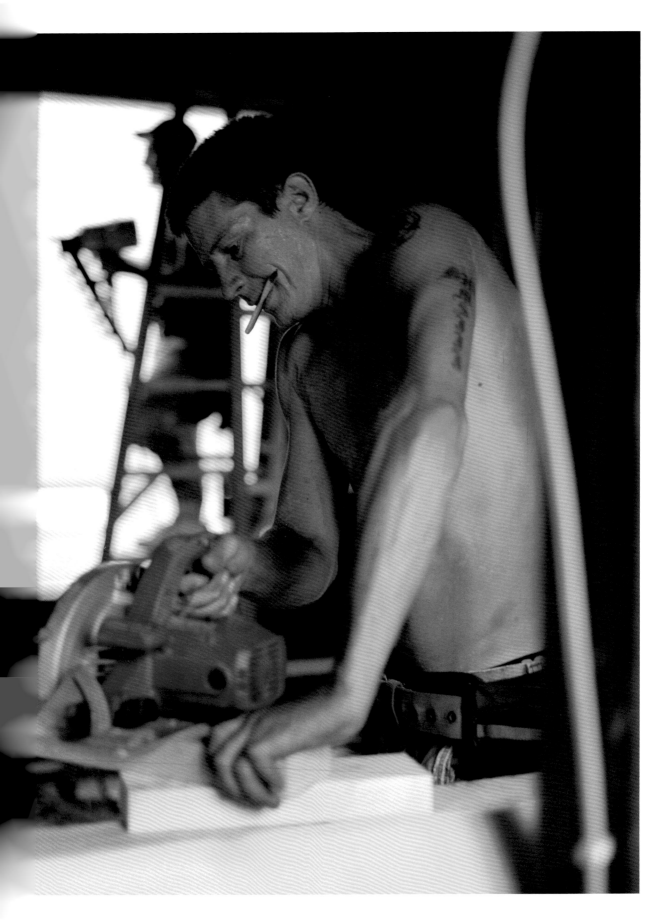

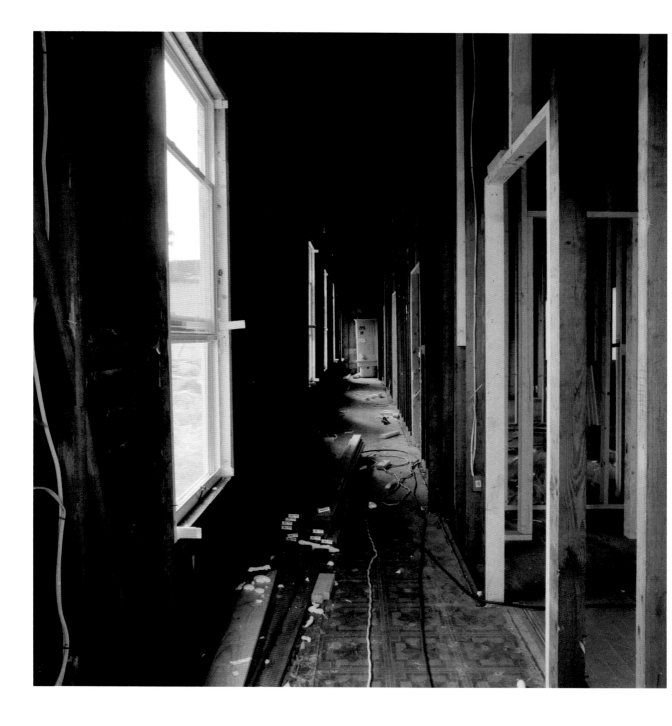

Maxine Richardson's hallway in July 2007 and April 2008.

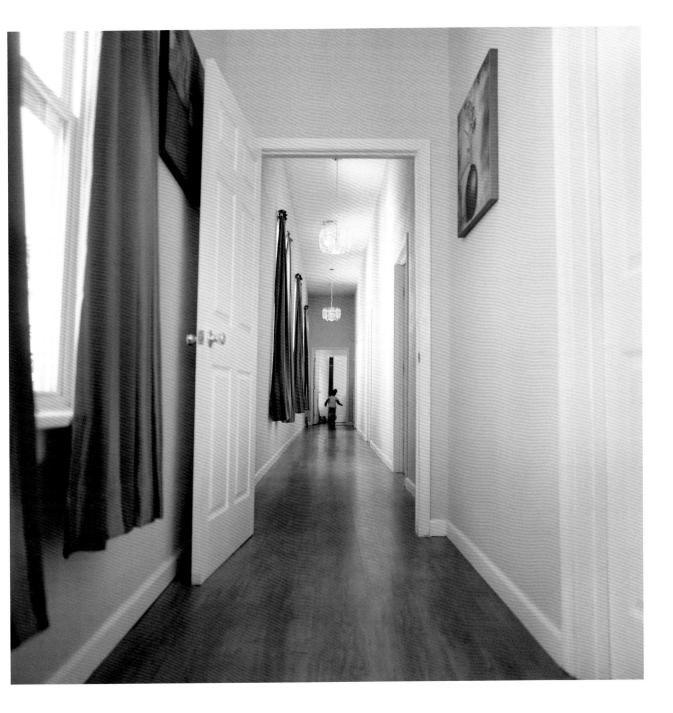

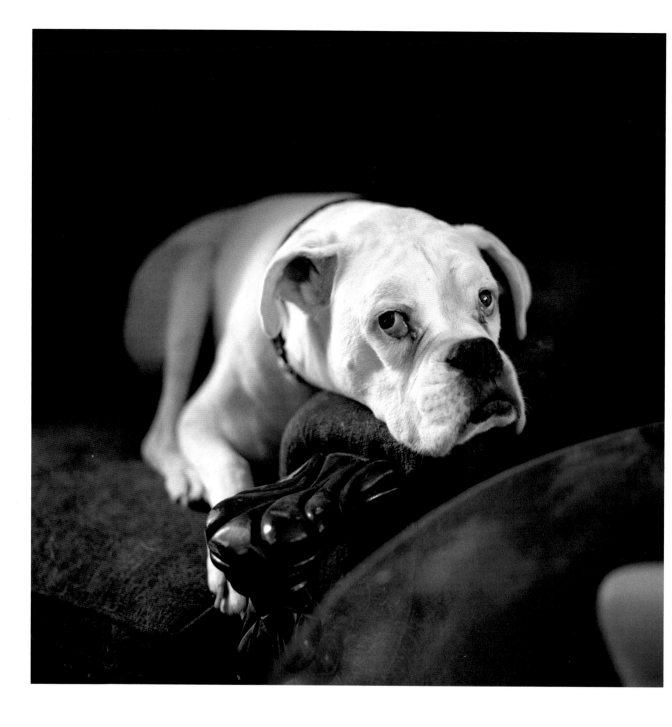

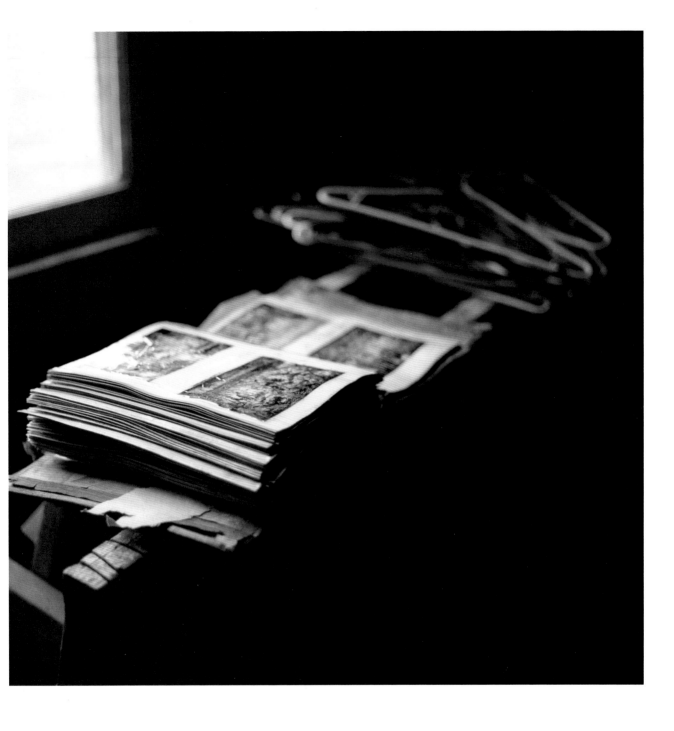

Danny Santiago's waterlogged photo-albums document a girls' volleyball team he and his wife coached for years. Danny continues to look through them lovingly, describing specific images in detail when virtually nothing remains but muddy whorls of ink.

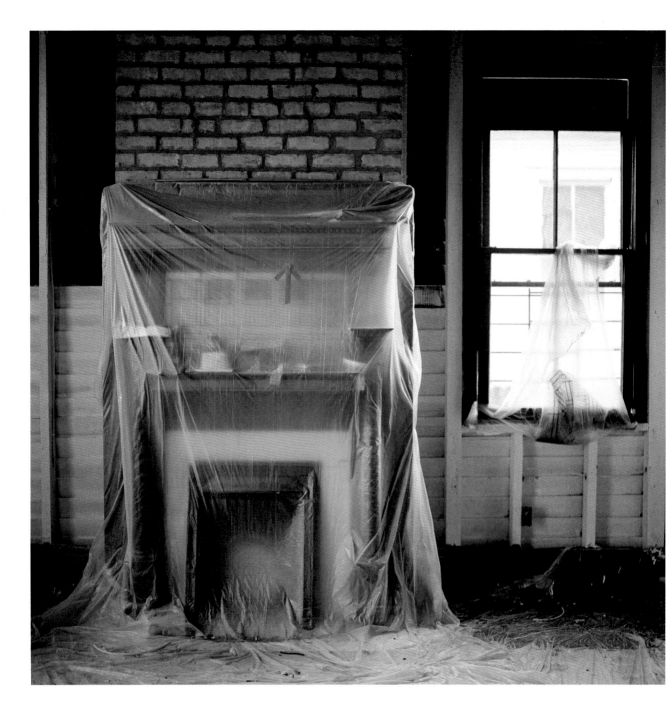

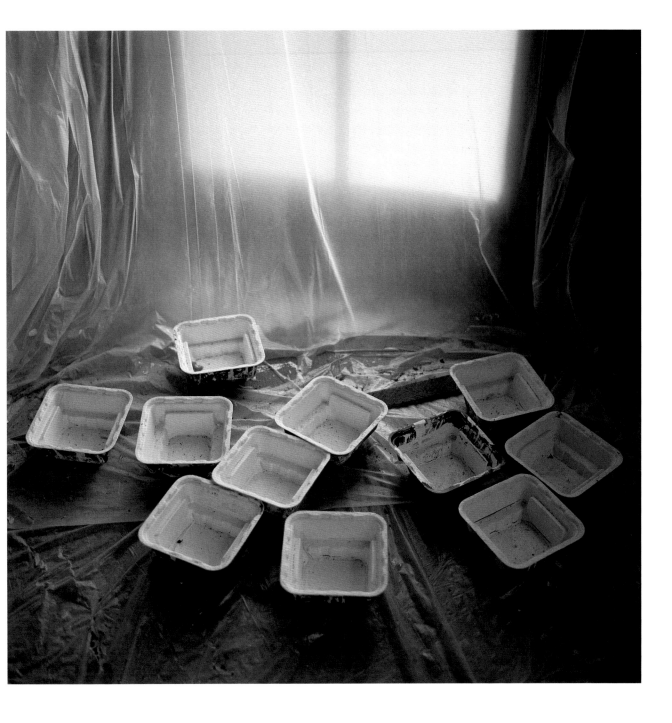

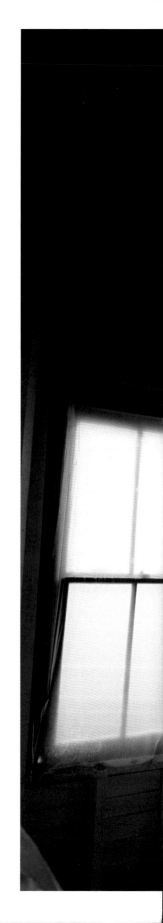

"If you have just a little bit of an eye for something that could become better, and you like to see the result of it become better, then this is paradise for you."
—Markus Wittmann

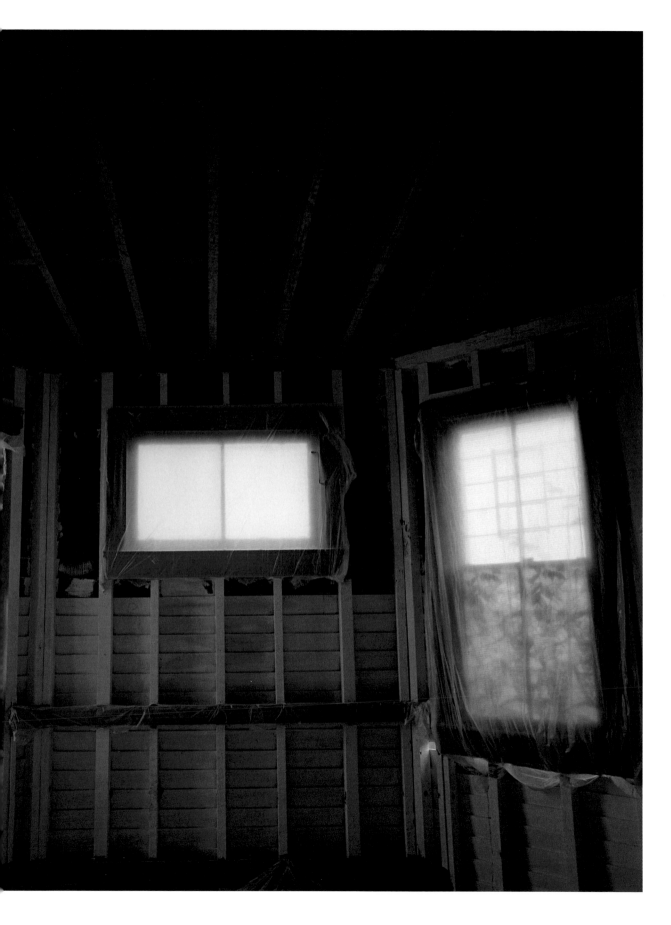

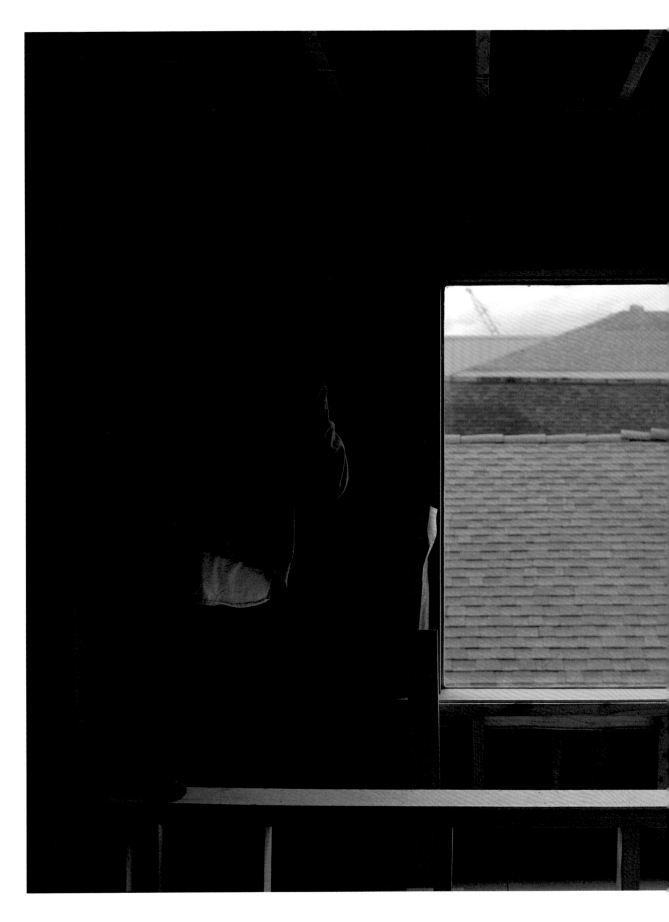

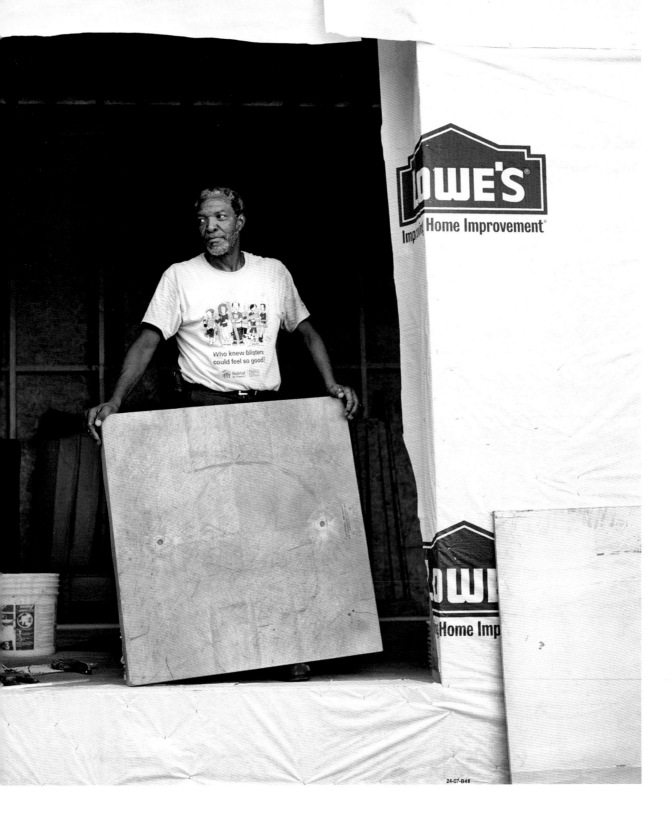

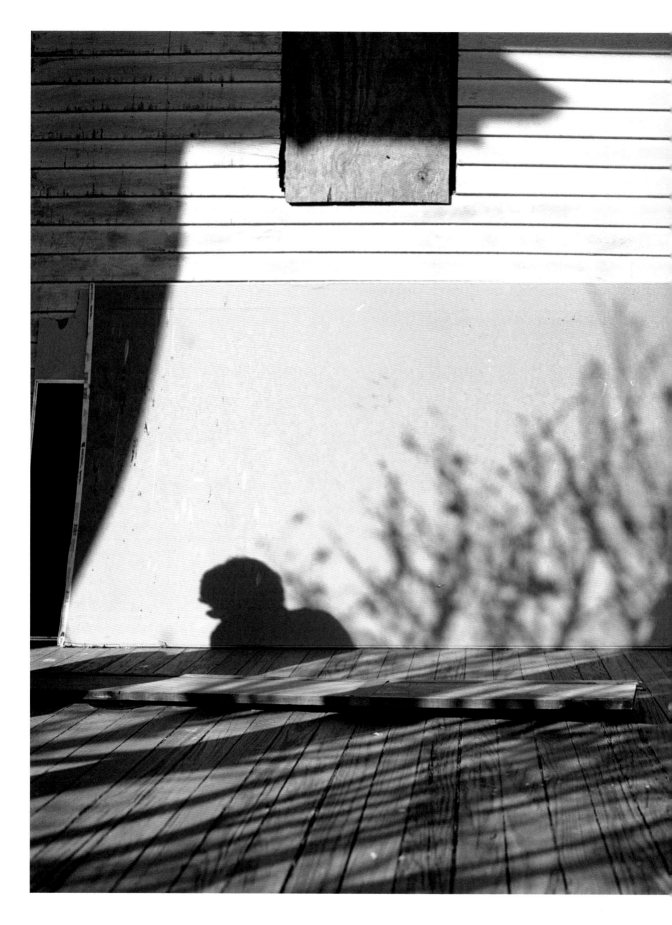

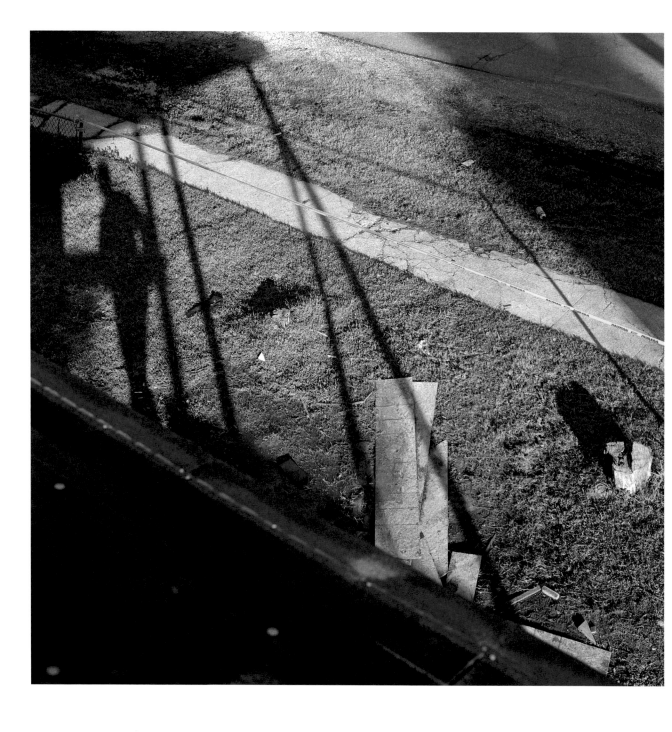

"You can't worry about what's not there anymore." —Maxine Richardson

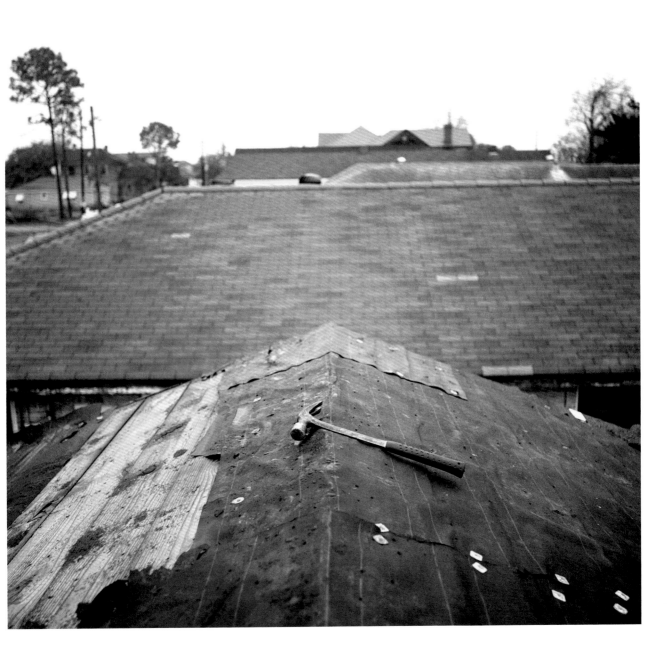

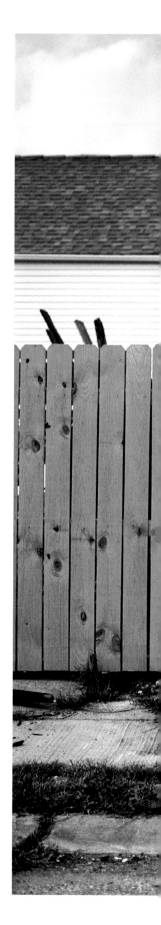

This fence was built on the site where Keith Calhoun and Chaundra McCormick's house once stood. The building collapsed during the storm, and the fence was constructed by two groups of Amish volunteers, on separate trips to New Orleans.

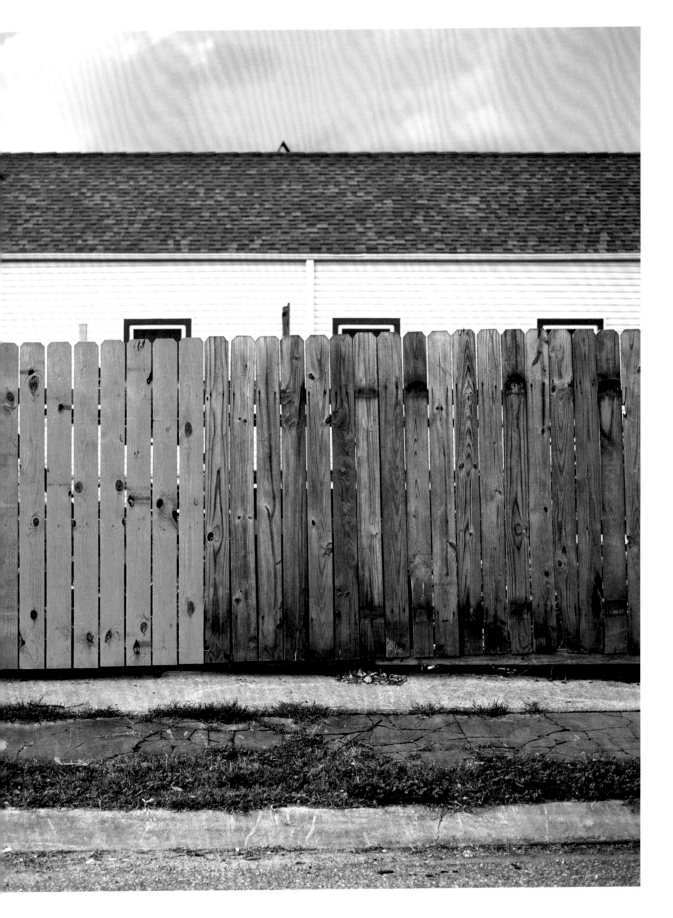

"A house with no one in it? It just withers." —Freddie Jones

"People want to get in as fast as they can, but you gotta take your time and think this shit through, man." —Bruce Harris, on his roof

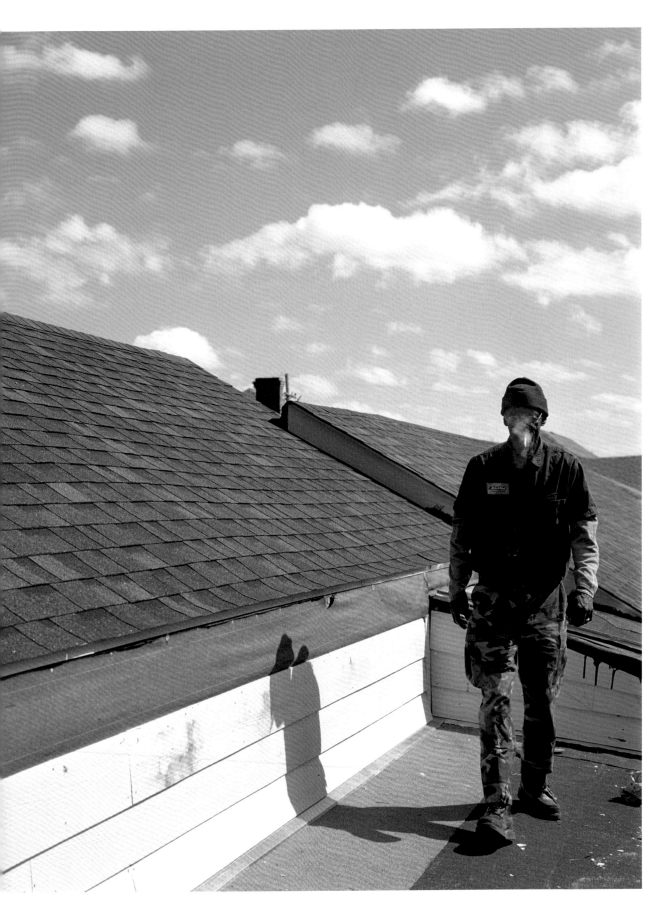

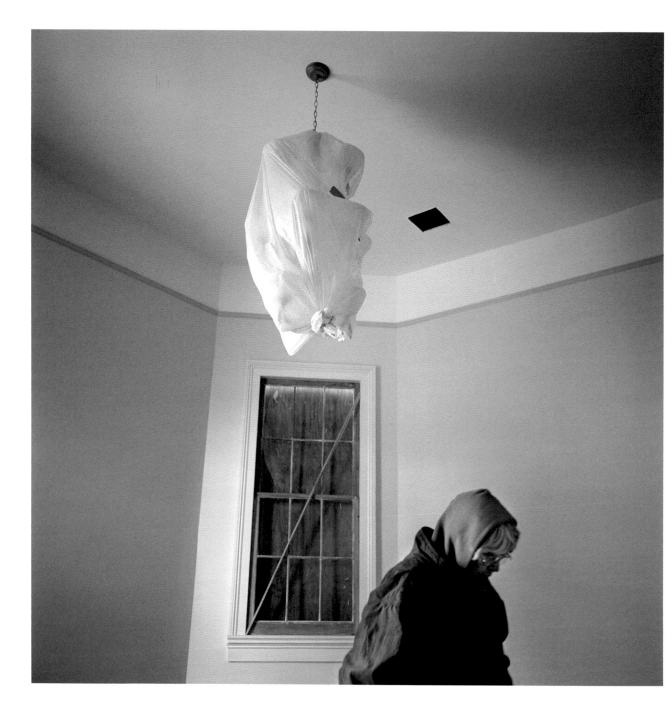

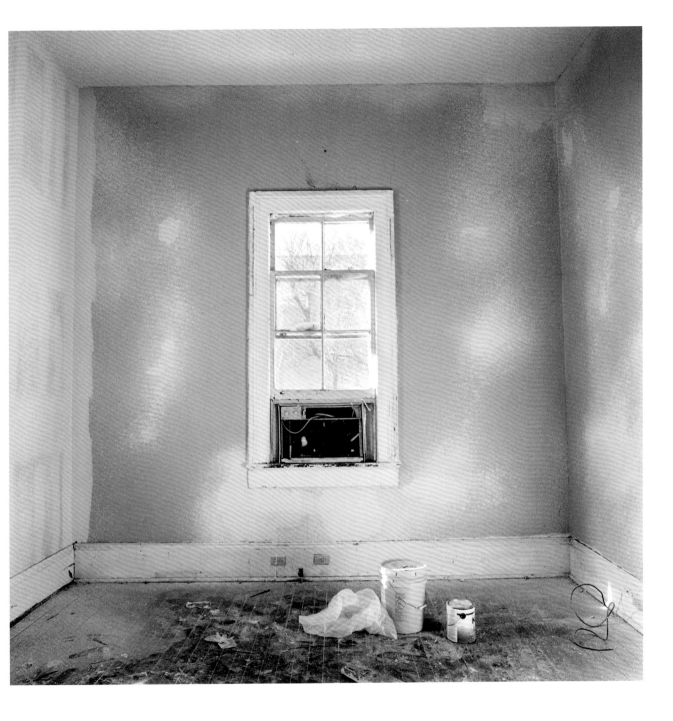

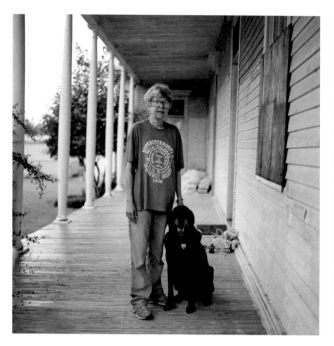 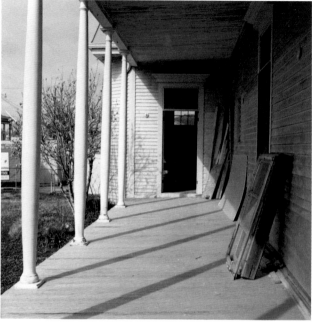

"I'm the door lady, the baseboard lady, the mantel lady, and the window lady. All those things you strip and fill and sand and caulk and sand some more and then prime and paint."
—Stacy Rockwood, on her porch, July 2007, January 2008, June 2008, and December 2009
(left to right)

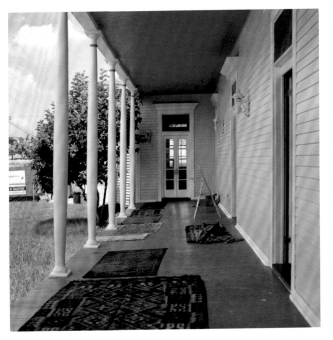 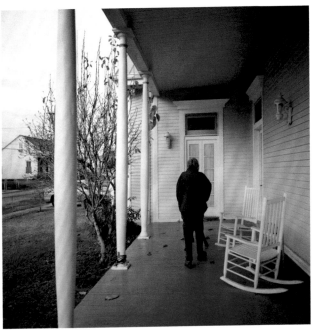

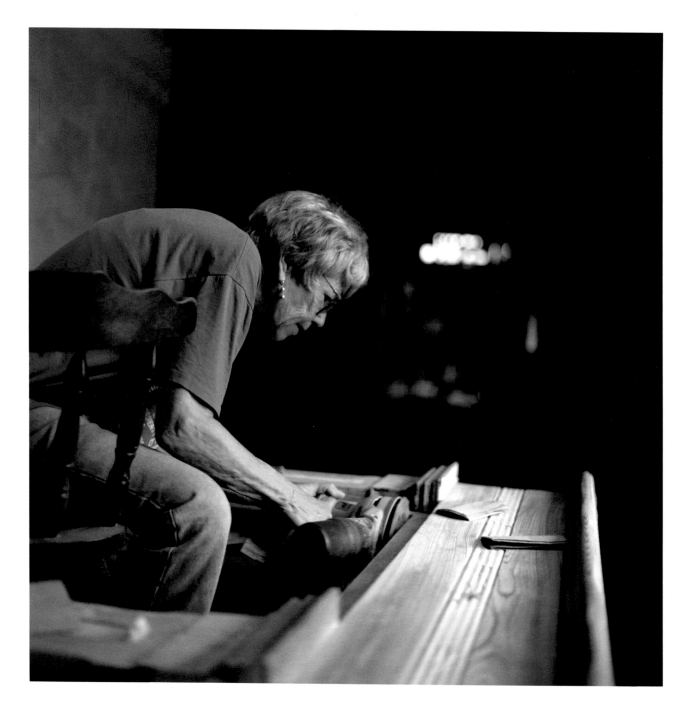

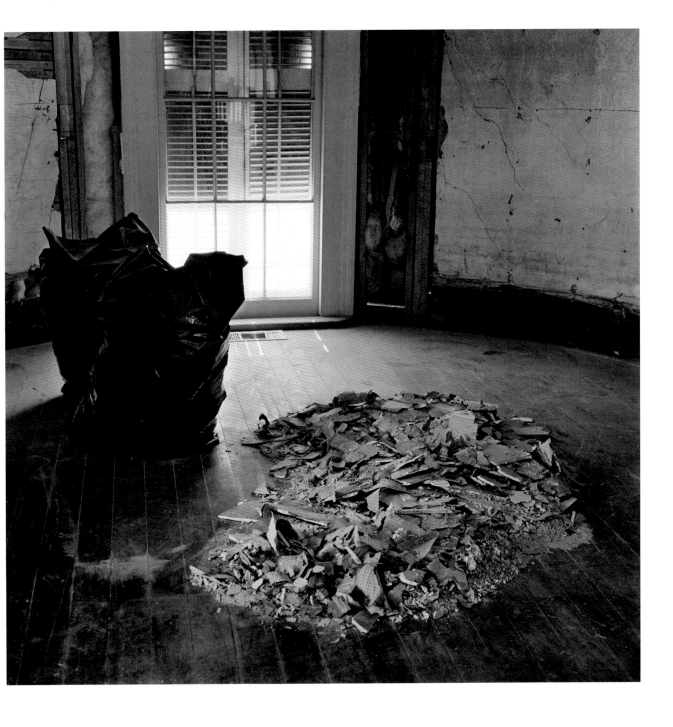

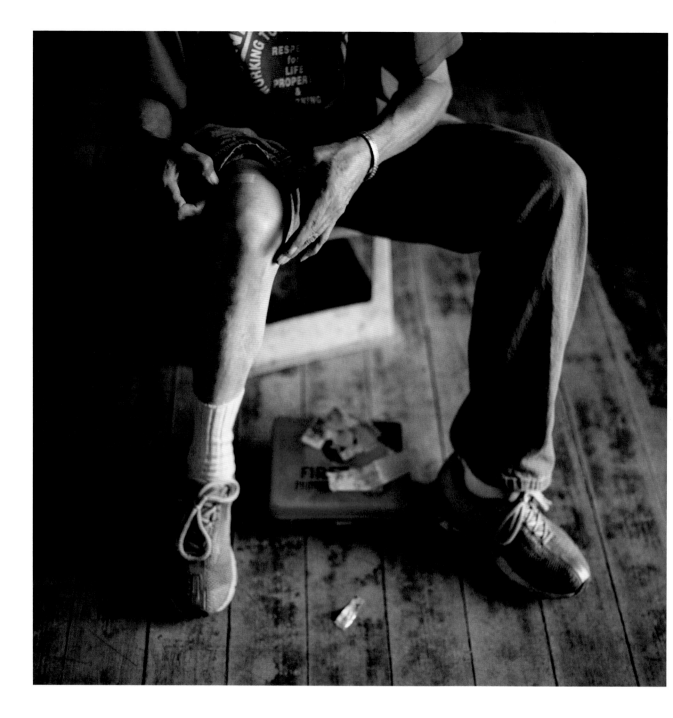

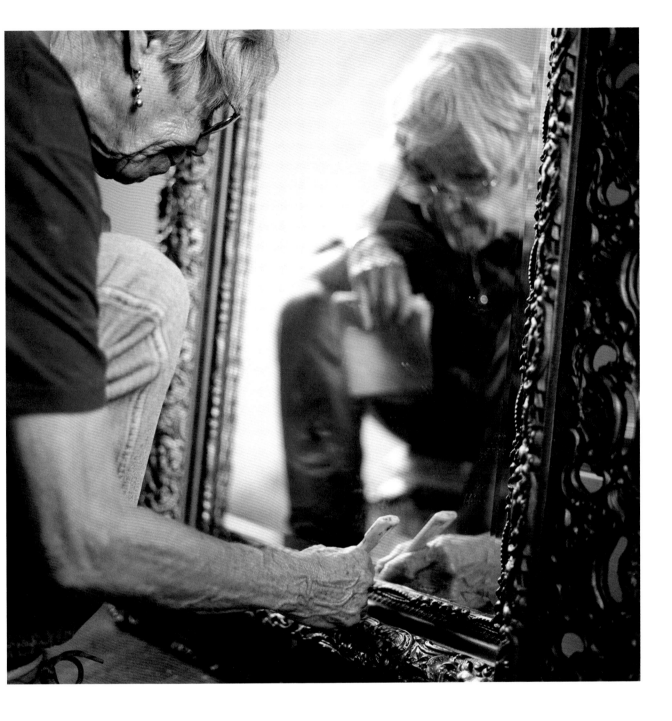

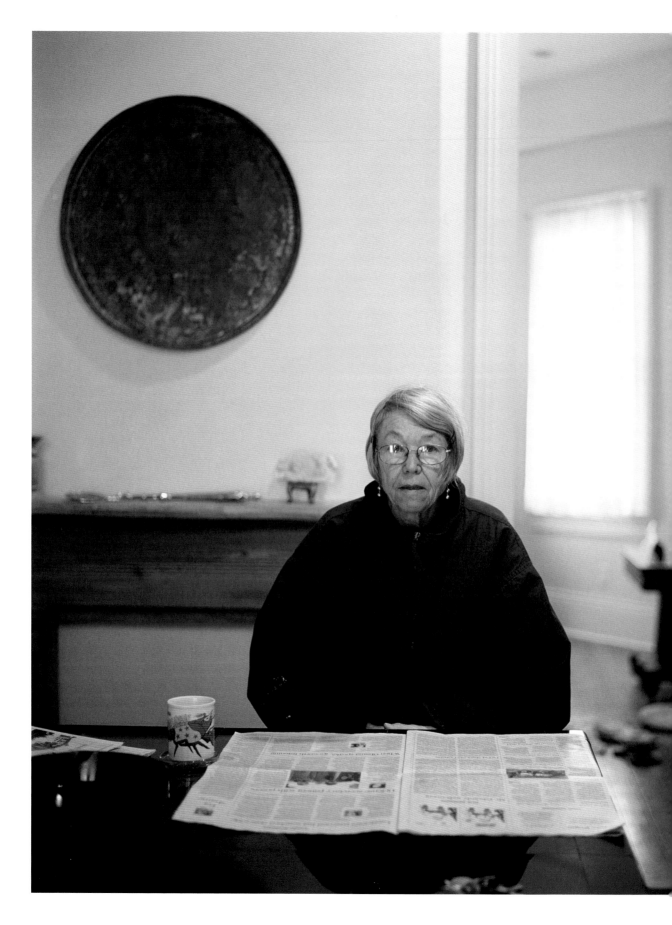

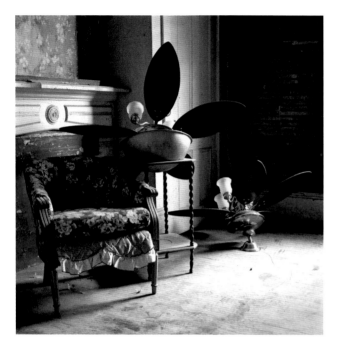

"This house is just beautiful. Never in my wildest dreams did I think I would get it all put back together like it is now." —Stacy Rockwood

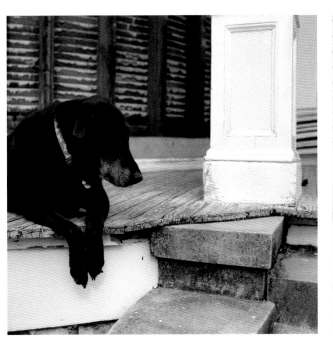

During her two-year renovation, and while living in a FEMA trailer, Stacy Rockwood's healthy Labrador retriever, Licorice, developed cancer and died. A subsequent study by the Centers for Disease Control and Prevention proved what many had long suspected: that FEMA trailers contained unsafe levels of toxic formaldehyde and were causing numerous health problems. Said Stacy, "I'm convinced that FEMA trailer killed Licorice."

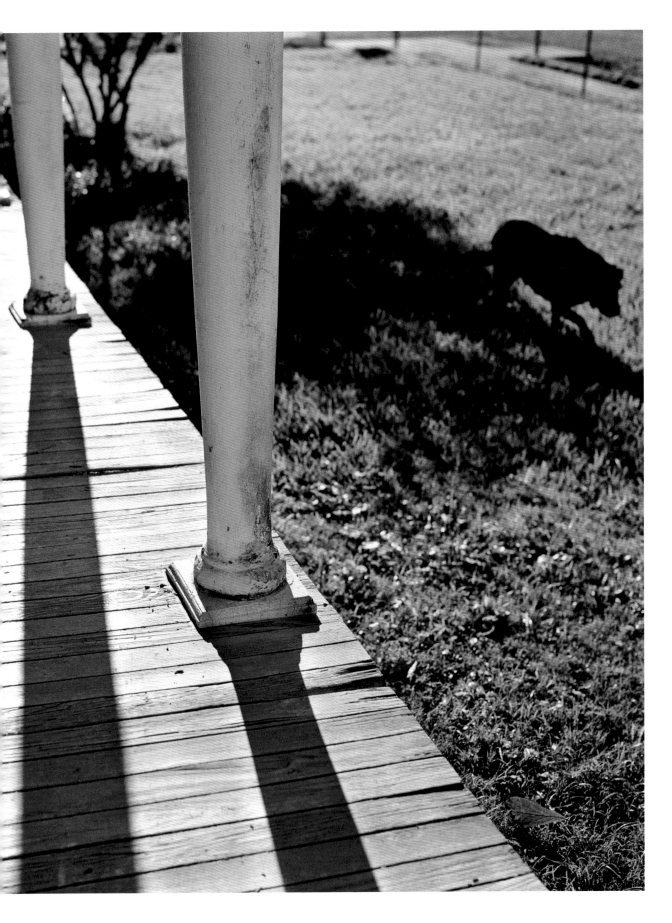

Sarah Lastie, widow of New Orleans jazz legend Melvin Lastie, sprays weed killer on the foundation of her half-constructed home. The city shut down the site after her contractor failed to build the structure to code, costing her over $10,000 in lost fees.

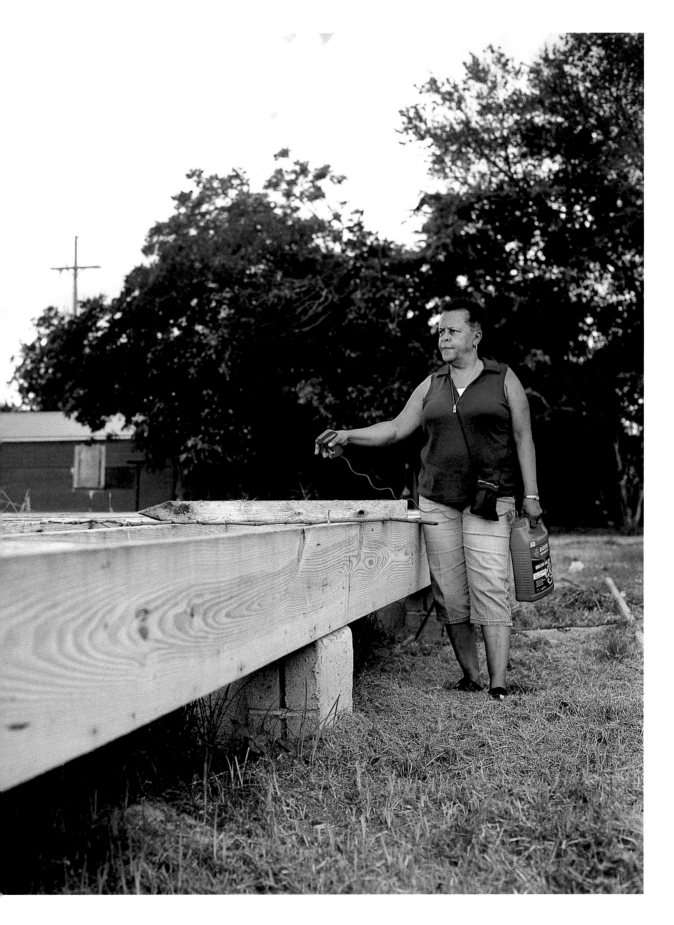

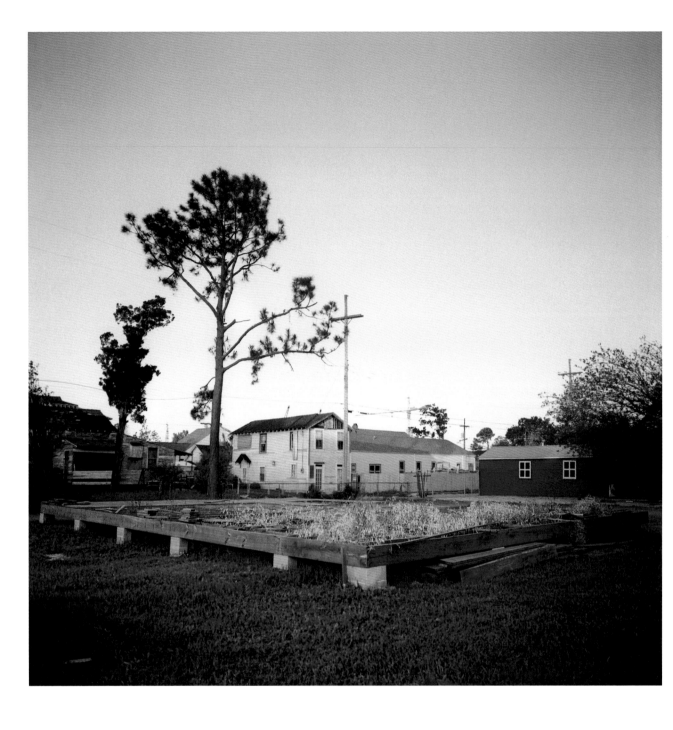

108 Weeds spring up on the site of the stalled Lastie home.

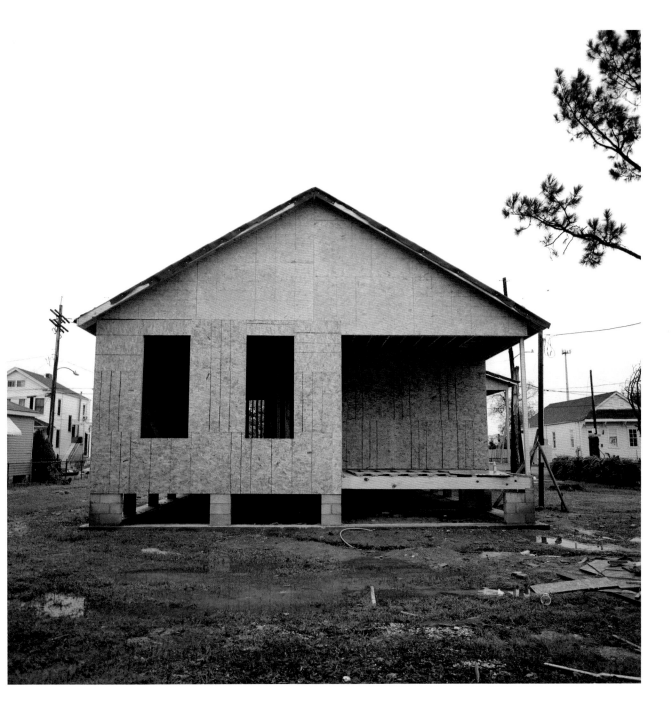

Construction on the Lastie home began again after artist Wangechi Mutu, inspired by Sarah's story, decided to donate proceeds from the sales of her work to fund its rebuilding. Mutu learned about Lastie when she was commissioned to do an installation on the property for the Prospect Art Biennial.

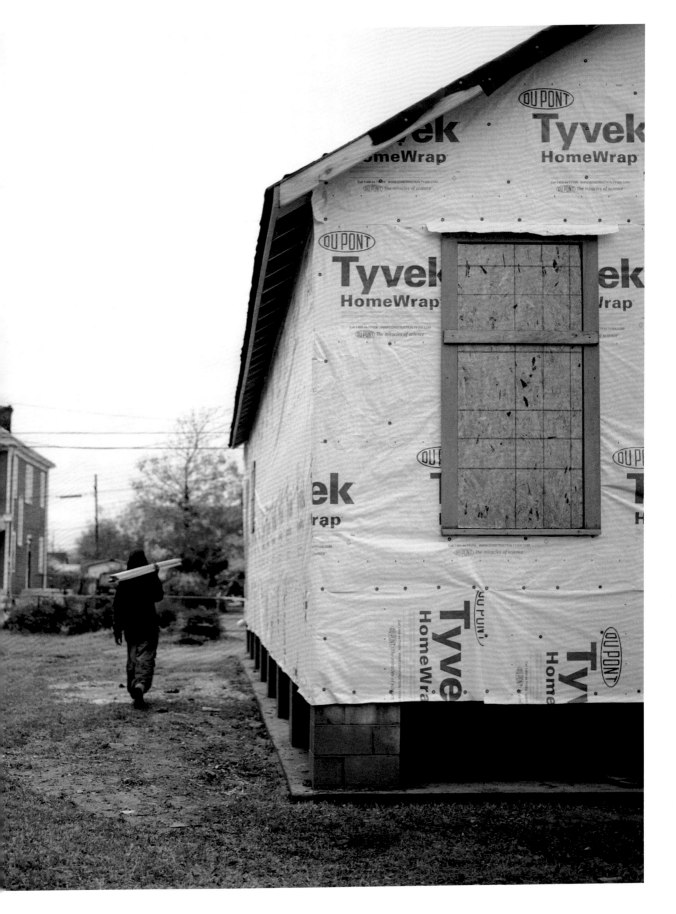

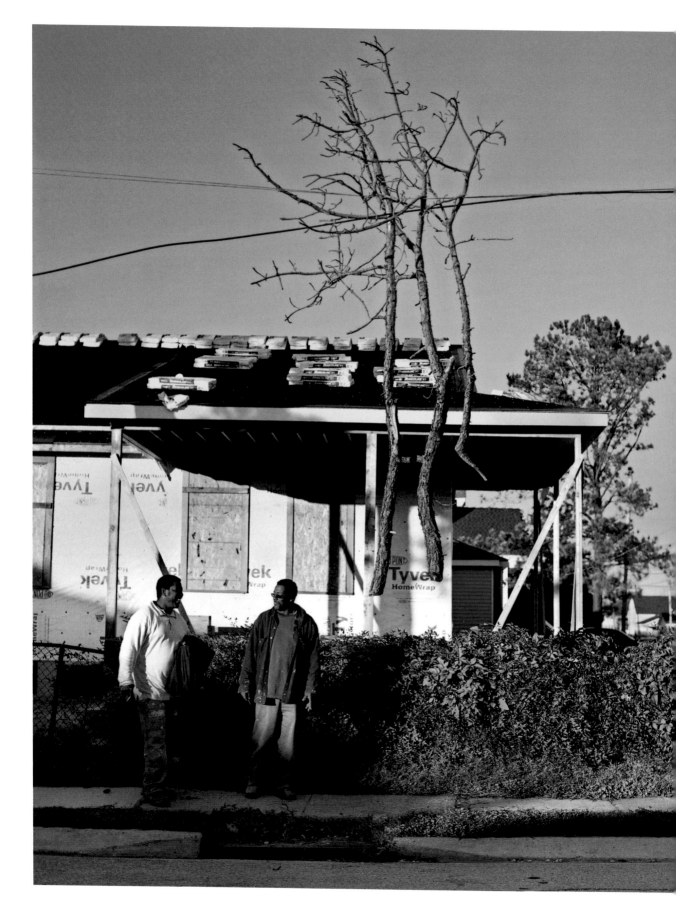

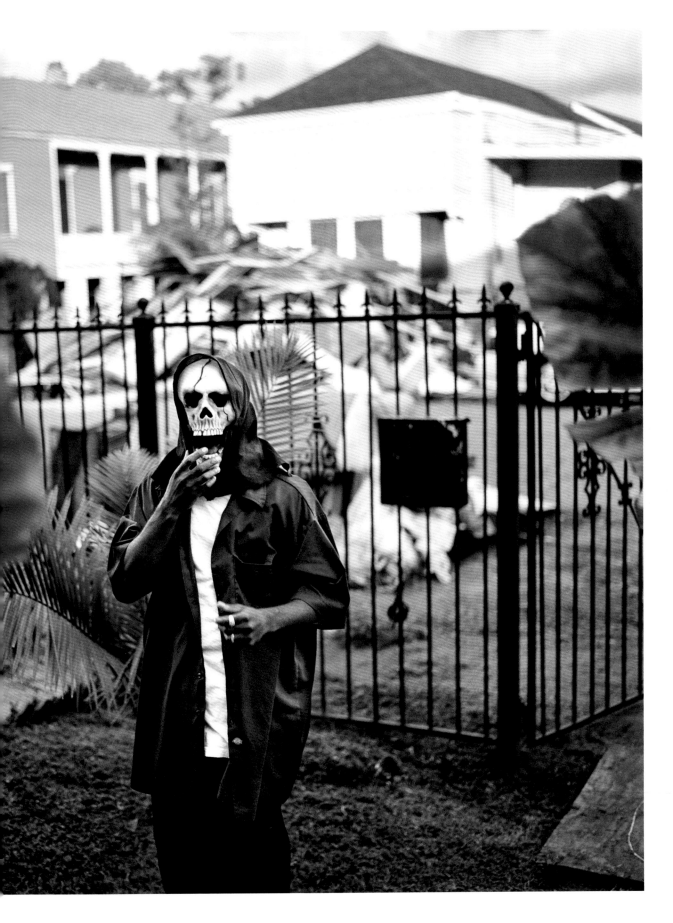

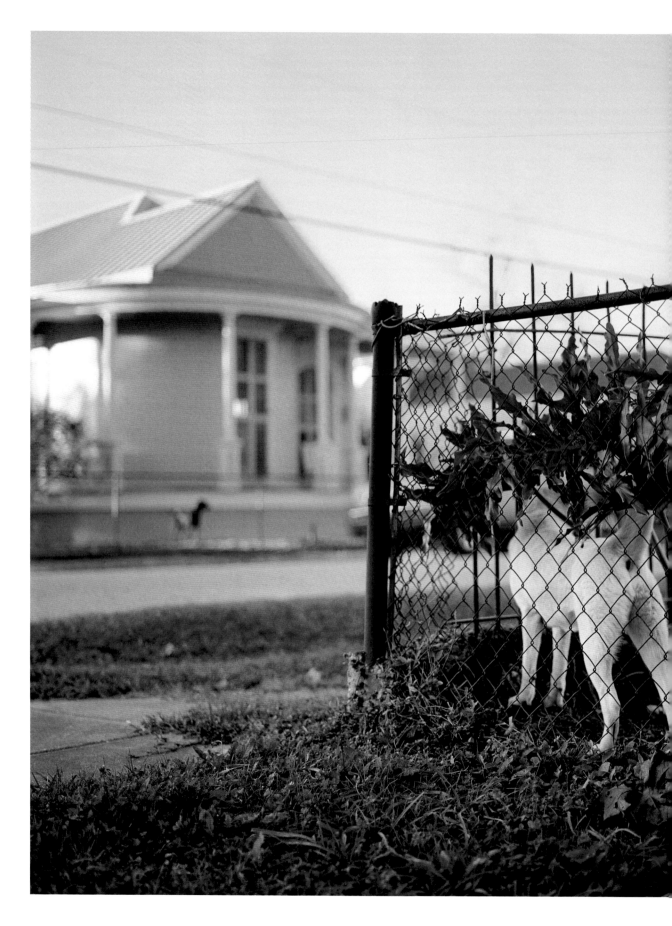

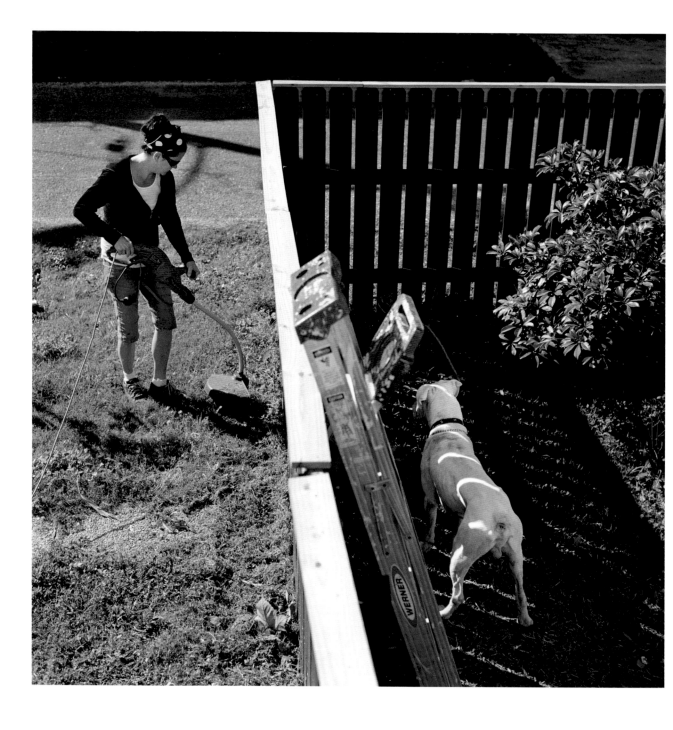

The sight of residents gardening again marked a milestone in the neighborhood's recovery.

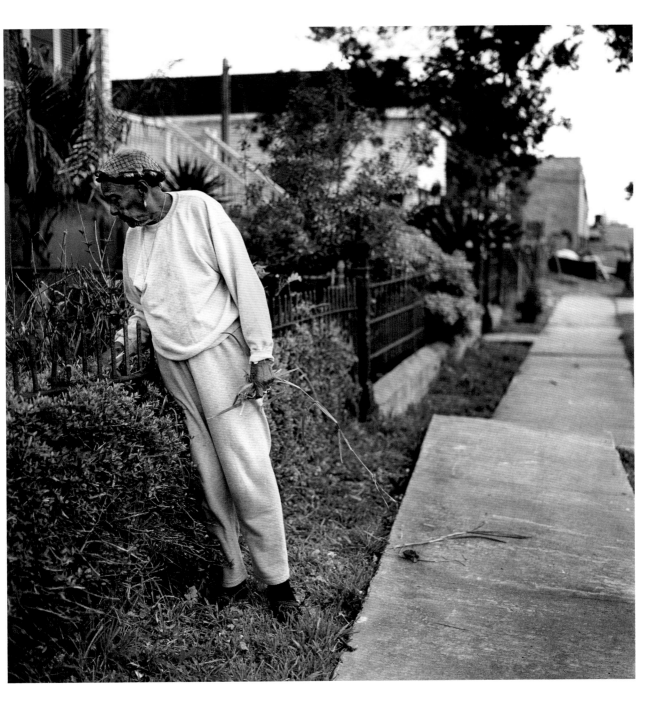

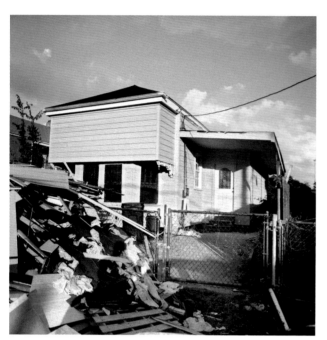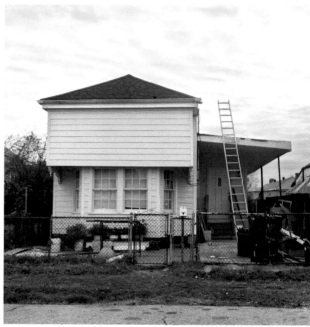

120 Alita and Bruce Harris's house in October 2007 and December 2009.

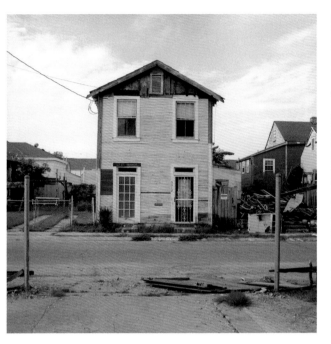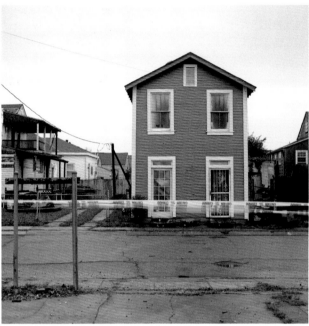

121 The Santiago house in June 2007 and December 2009.

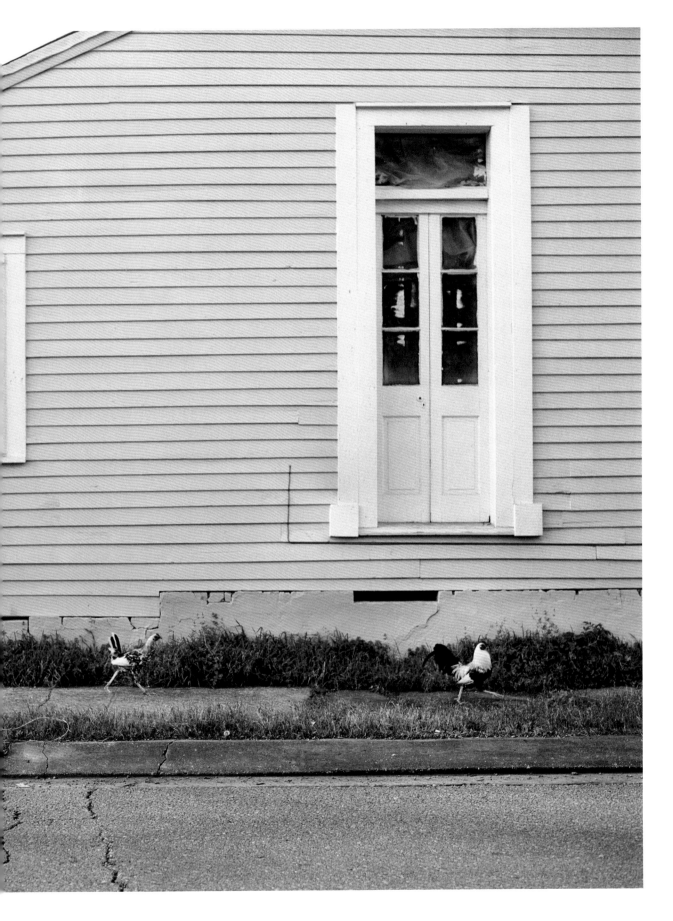

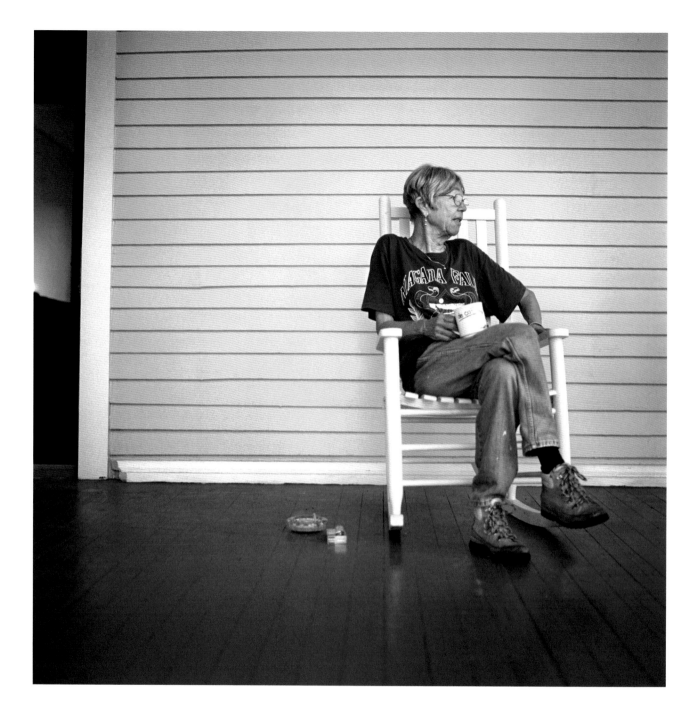

Stacy Rockwood relaxes with her sister, Tuckie, following the completion of her home. Tuckie and her husband came to New Orleans on several occasions to help Stacy with the cleanup and rebuilding.

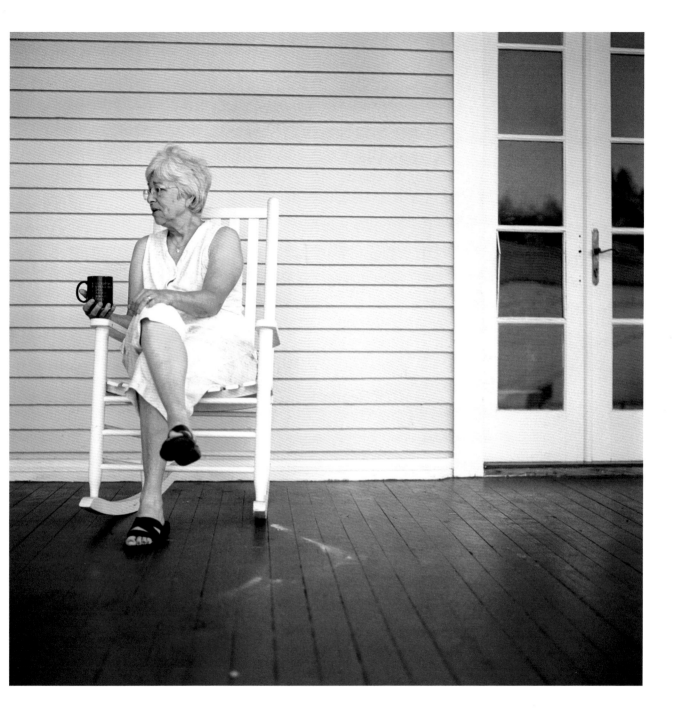

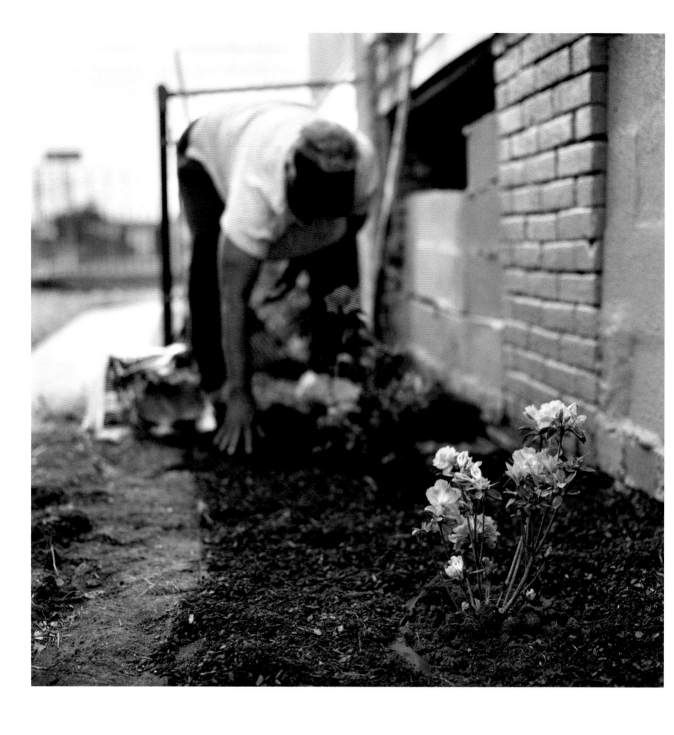

"On my way here I couldn't stop thinking about the yard. So I stopped at the Home Depot and picked up the roses. That felt so great." —Augustine Greenwood

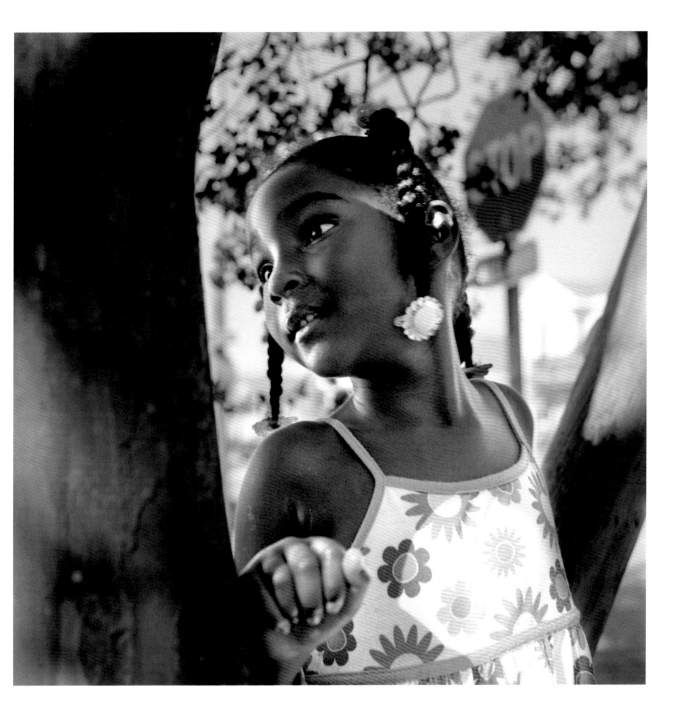

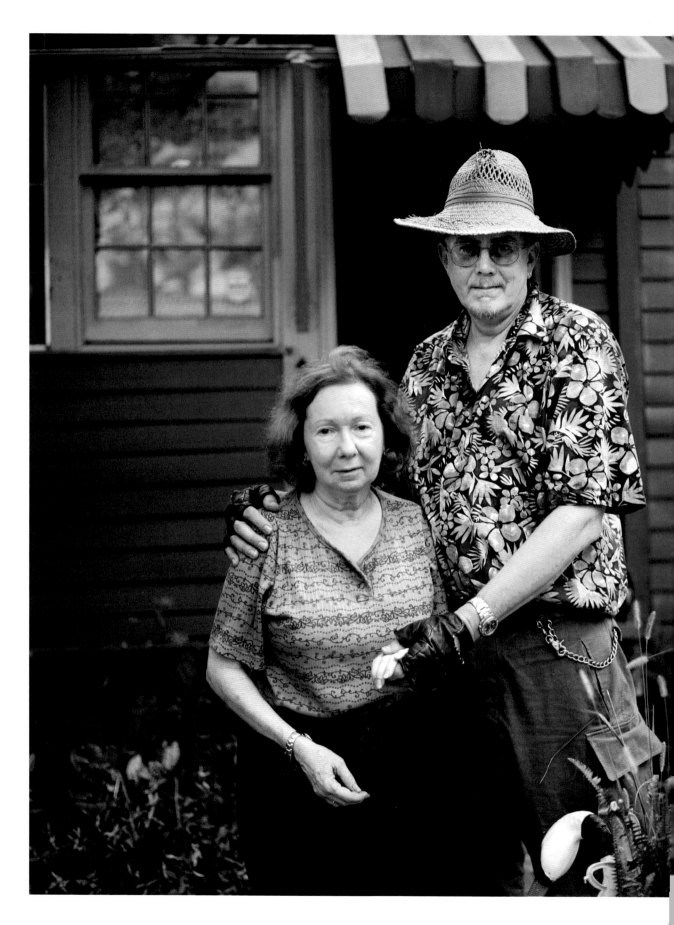

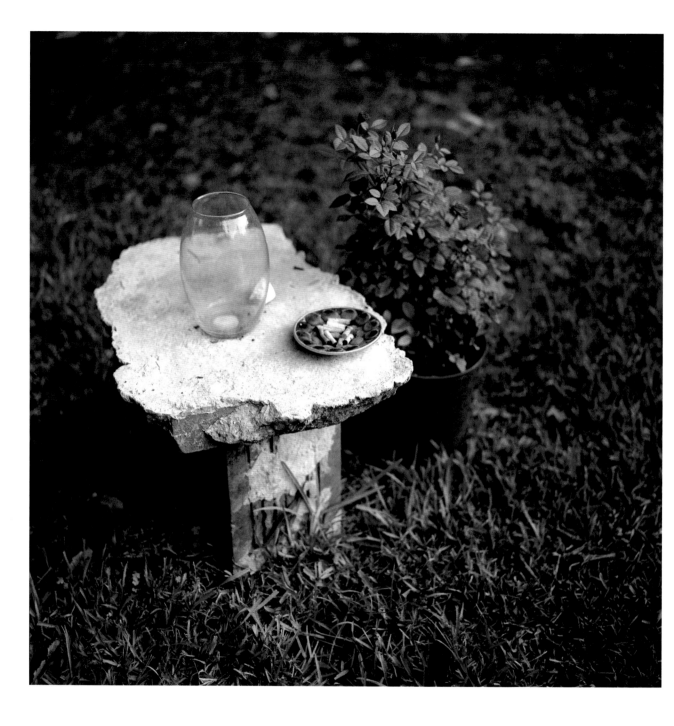

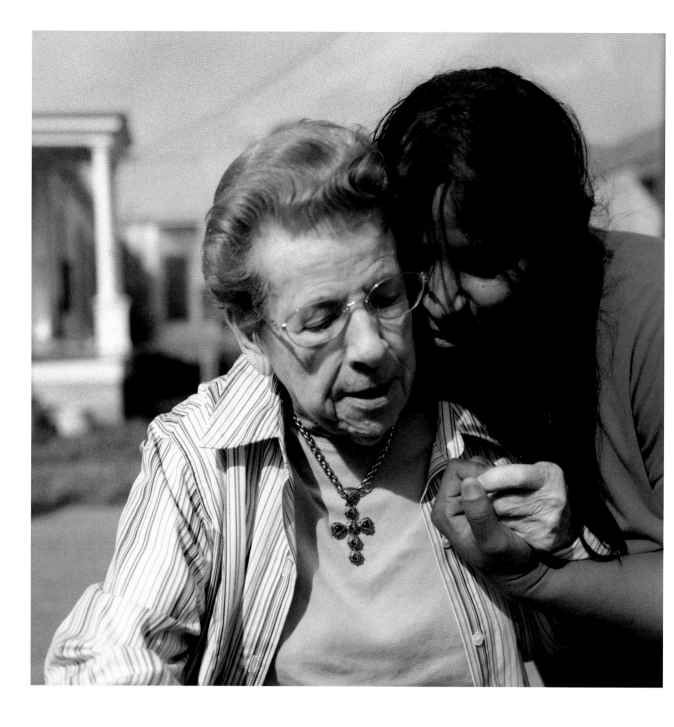

Doris Cefalu had lived on the block longer than anybody in the neighborhood when the storm hit. A beloved figure with a salty tongue, she was heartbroken when her home was destroyed and she was forced to move in with her daughter, across the river in Gretna. The sight of her former home always makes Doris cry. She is with Augustine Greenwood's daughter, Sheila McCutcheon (left), and with Augustine, Stacy Rockwood, and Sheila (right).

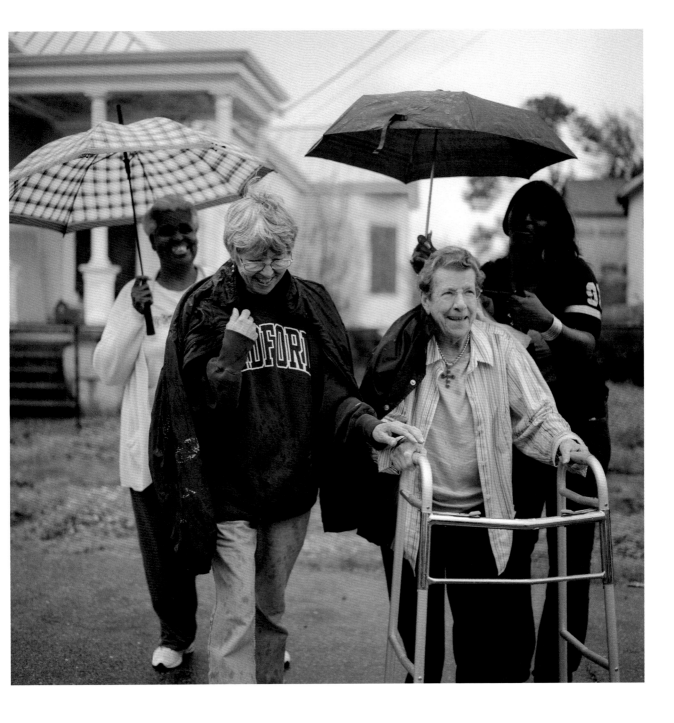

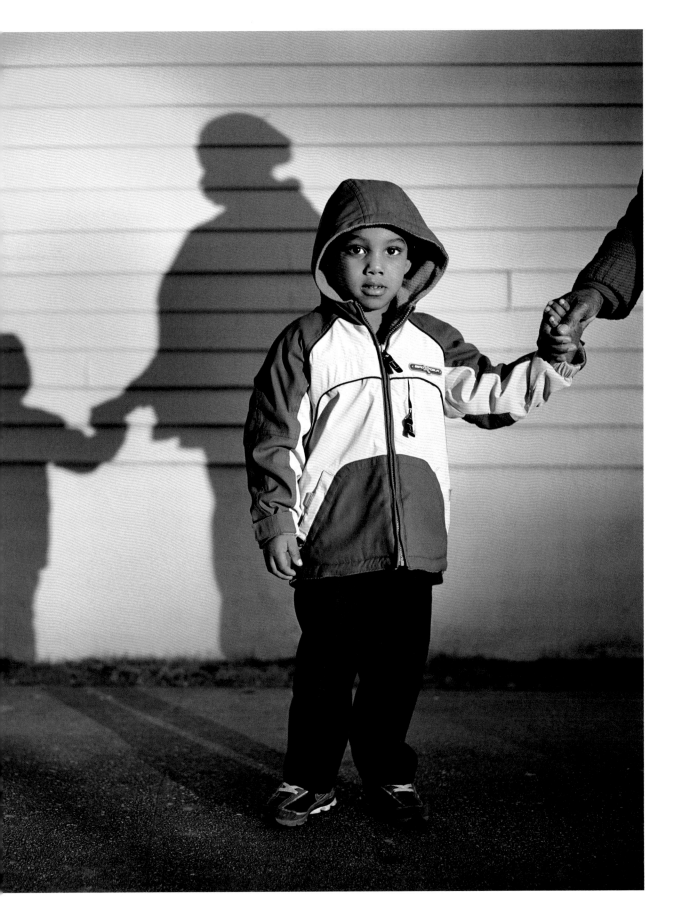

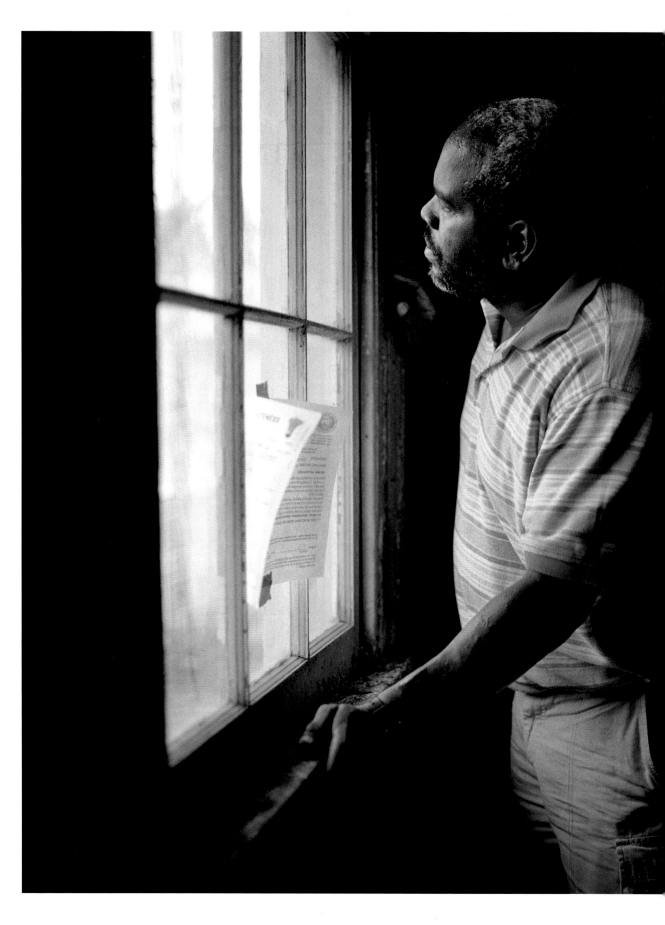

While many residents have finished their renovations and moved home, others, like Danny Santiago and his wife, still face significant obstacles.

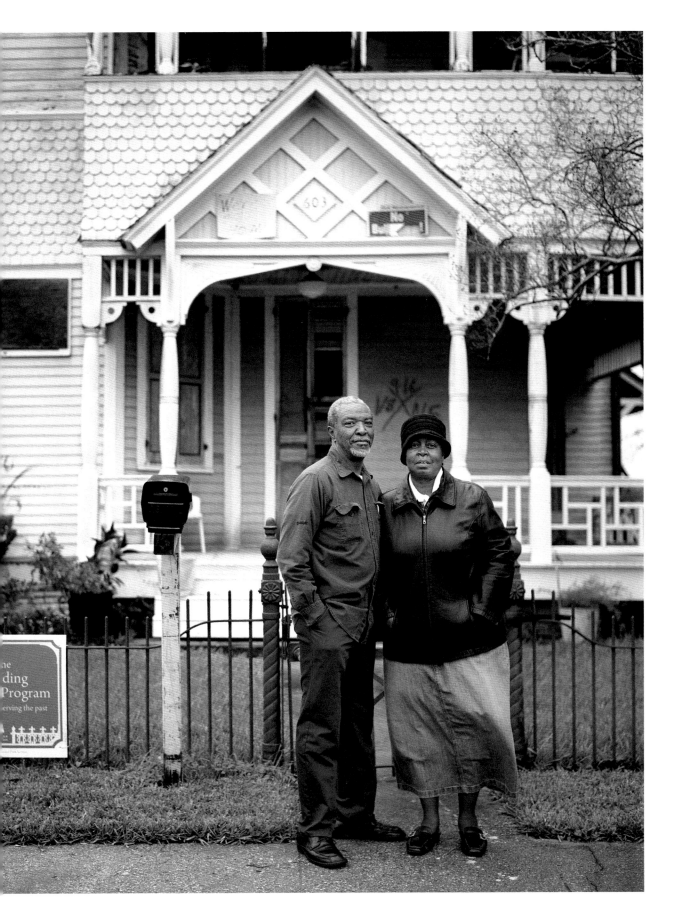

ACKNOWLEDGMENTS

For Dad, whose love of art and pursuit of social justice provide so much inspiration.

• • •

I first thank Ashley, who put up with my travels while raising a wonderful boy. Thanks also to Judy and Don Adams for their constant support of our family; especially while I was gone. And a most special thanks to Dad for his incredible belief in this project.

Photography is an invasive process and photographers often get far more credit then their subjects despite the fact that without a willing subject and a story to tell, a photographer is lost. And of course it is those subjects whose time is taken and whose lives are on display. So I must thank the wonderful people of this block in the Holy Cross neighborhood of New Orleans's Lower Ninth Ward for allowing me into their lives at a time of such intense stress and anxiety. I am even more grateful to have been allowed to return so many times over a period of several years. First, thanks to the incredible Markus Wittmann and Lisa Perilloux, who put a roof over my head, fed me, and made me family. A big thanks also to Stacy Rockwood, Mack McClendon, and John Washington for being so welcoming and helping me to understand the neighborhood. I would also like to thank everyone else on the block for their openness, hospitality,

and generosity with their time. I am proud to now call many of them friends: Augustine Greenwood, Sheila McCutcheon, Maxine Richardson, Hermanese and Sheena Rogers, Calvin and Nathalie Alexander, Bruce and Alita Harris, Chris and Marjorie Olmstead, Doris Cefalu and Gayle Marino, Otheodore Solomon, Keith Calhoun and Chaundra McCormick, the Phoenix family, Charles and Raquel Johnson, Eloise Gibson, Landry Duchane, Danny Santiago, Gregory McMorris, Manfard Sorell, Angela Washington, Freddie Jones, Richard and Michelle Powell, James and Edell Clark, and Sarah Lastie. I would also be remiss not to thank the many skilled workers who helped put the neighborhood back together and allowed me to record their process.

Choosing this block from among so many unique neighborhoods was no small task and I did not approach it scientifically. I solicited lots of advice and traveled to as many parts of the city as I could before settling on this, the 500 block of Flood Street and Caffin Avenue. And since I am not a sociologist, economist, historian, urban planner, community leader, or even New Orleanian by birth, I was very dependent on getting good advice from those who were and are experts on the city. I'd like to thank Renee Lapeyrolerie for driving me all around New Orleans, including down the stretch of Caffin Avenue that I

eventually chose. Also of critical importance were John Lawrence at the Historic New Orleans Collection, Jim Amdal at the University of New Orleans Department of Planning and Urban Studies, and both Stephanie Bruno and Maryann Miller of the Preservation Resource Center which, more than any other organization, has helped rebuild the Holy Cross neighborhood.

This book wouldn't be the same without the wonderful essay that opens it and I am deeply indebted to Chris Rose for his beautiful encapsulation of New Orleans in the years following the storm. And though he's barely stepped foot in the city, I am so grateful to the brilliant TJ McCoy for fashioning an outstanding first design of *One Block,* which contributed so much to the success of this project.

Many more provided critical help in the form of advice, introductions, and support of all kinds, including: Tim Hyde, Jennifer Soros, Joan Morganstern, Farai Chideya, Jessica Arons, Stephen Berkman, Chad Boettcher, Amanda Branson-Gill, Susan Burnstine, Beth Butler, Latoya Cantrell, Julie Casemore, Mike Chylinski, Brian Clamp, Chris Clement, Shamus Clisset, Julian Cox, Catherine Couturier, Brad Cushson, Jeff Eller, Josh Fine, Roy Fluchinger, Peggy and Julian Good, William Greiner, Mariah Hatta, David Houston, Lee Isaacson, Ben Krain, Nathan Larson, Dewi Lewis, Tommy Lewis, Jeff and Vanessa Louviere, Sarah Madsen, Lynn McLaughlin, Ian McNulty, Steve Naplan, Nancy Nolan, Ed Osowski, Rica and John Orszag, Allison Plyer, Randy Punley, Preuit Rauser, John Rohrbach, William Ropp, Skip Rutherford, Warwick Sabin, Ricki Seidman, Jennifer Shaw, Mark Sloan, Susan Spiritus, Mark Strama, Mary Virginia Swanson, Brad Temkin, Anne Tucker, Lori Waselchuk, David Winkler-Schmidt, and Connie and Stephen Wirtz.

Perhaps most significantly, I want to thank the people without which this book would not exist; chiefly, Maarten Schilt, who believed in it from the start and Denise Wolff, whose great eye, common sense, and gently firm approach elevated the project significantly. Thanks to everyone else at Aperture and DAP, especially Lesley Martin for her longtime support of my work, Jane Brown, who believed in *One Block* from the get-go, Andrea Smith for letting the world know about it, and the talented Inger-Lise McMillan for her outstanding final design. I would also like to thank Faye Robson, Simone Eißrich, and Susan Ciccotti for their many contributions to this project. And a big high-five to Mary Togni, who put almost as many hours into *One Block* as I did, and whose many great ideas made it significantly better.

And finally, hats off to the people of New Orleans. What an awesome town.

Front cover: Fence on the site where Keith Calhoun and Chaundra
 McCormick's house once stood.
Back cover: Maxine Richardson in her FEMA trailer.

Editor: Denise Wolff
Designer: Inger-Lise McMillan

The staff for the Aperture edition of *One Block: A New Orleans
Neighborhood Rebuilds* includes: Juan García de Oteyza, *Executive
Director*; Lesley A. Martin, *Publisher, Books*; Susan Ciccotti, *Senior
Text Editor, Books*; Matthew Pimm, *Production Director*; Julia
Barber, Faye Robson, and Simone Eißrich, *Work Scholars*

One Block was made possible, in part, with generous support from
Jonathan and Jennifer Allan Soros.

For more information, and to help New Orleans residents still
rebuilding, please go to:

Preservation Resource Center of New Orleans
www.prcno.org

Lower 9th Ward Village
www.lower9thwardvillage.org

www.dbanderson.com

First Aperture edition
Printed in Germany
10 9 8 7 6 5 4 3 2 1

Library of Congress Control Number: 2010904545
ISBN 978-1-59711-143-0

Aperture Foundation books are available in North America through:
D.A.P./Distributed Art Publishers
155 Sixth Avenue, 2nd Floor
New York, N.Y. 10013
Phone: (212) 627-1999
Fax: (212) 627-9484

aperturefoundation
547 West 27th Street
New York, N.Y. 10001
www.aperture.org

The purpose of Aperture Foundation, a non-profit organization, is
to advance photography in all its forms and to foster the exchange
of ideas among audiences worldwide.